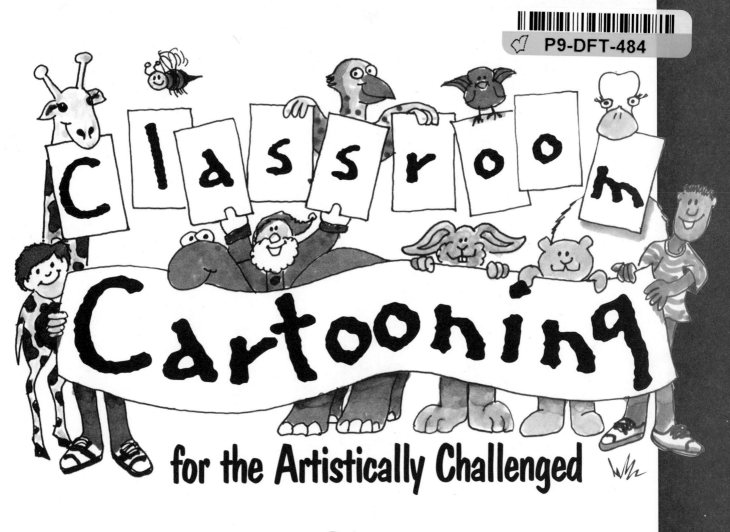

Classroom Cartooning

for the Artistically Challenged

by
Mike Artell

C'mon... Let's get drawing!

Good Year Books
Parsippany, New Jersey

Good Year Books

are available for most basic curriculum subjects plus many enrichment areas. For more Good Year Books, contact your local bookseller or educational dealer. For a complete catalog with information about other Good Year Books, please write:

Good Year Books
An imprint of Pearson Learning
299 Jefferson Road, P.O. Box 480
Parsippany, NJ 07054-0480
www.pearsonlearning.com
1-800-321-3106

Design by Christine Ronan Design.
Copyright © 1997 Mike Artell.
All Rights Reserved.
Printed in the United States of America.

ISBN 0-673-36208-6
5 6 7 8 9 - ML - 06 05 04 03 02 01

A note to. . . Parents and Teachers

Cartoons are magic. With a few simple lines, you can create a crazy dinosaur or a talking computer. But the real magic is the way a room full of chattering, wiggly kids will suddenly "lock in" when someone begins drawing a cartoon on the board, overhead, or easel pad. I know, because every year I visit thousands of students at schools across the country, and it's the same in every school. All I have to say is, "Let's take our pencils and paper and draw." From then on, I have their total attention.

Contrary to the opinion of some that cartooning is "frivolous," I've seen creative adults use cartoons to illustrate concepts in math, science, and social studies; improve fine motor skills; and encourage innovative thinking. When we encourage students to create their own books, cartooning becomes a terrific tool for generating story ideas and developing plots.

A Note to Parents and Teachers

Classroom Cartooning for the Artistically Challenged is for adults who understand the importance of visual elements to learning. If you are one of those adults, you probably already have posters, signs, and children's work stuck all over the walls in your home and classroom. As you use this book and develop your cartooning skills and those of your students, you'll find a hundred new ways to incorporate visual elements into your posters, handouts, notes, study sheets, and interior environment.

Even if you are "artistically challenged," you'll be amazed by the drawings you can create. As you draw, remember that you don't have to be a great artist to be a good cartoonist, but you do have to be able to think in fresh, fun ways. So have fun with this book. Experiment. Play. Open your mind to thinking funny. Cartoons, like education, should delight you and your children.

Mike Artell

How to Use This Book

It's always a little tricky suggesting how a book ought to be used. Clever parents and teachers come up with wonderful ideas that the author never considered. Nevertheless, I'd like to share some thoughts that I have regarding the use of this book.

First, this book can be used as a "how to draw cartoons" book. The drawings on each page are simple, and virtually all of them can be executed in six steps. You can conduct a drawing lesson by guiding children through each step.

Second, you can use Classroom Cartooning for the Artistically Challenged to illustrate concepts across the curriculum. For example, if you're teaching a lesson on the three states of matter (solid, gas, liquid), you could draw an owl sitting on a branch from which are hanging icicles (solid water). You could then draw a lobster in a pot full of steaming water (water as a gas). And finally,

How to Use This Book

you could draw a beaver in a pond with a raindrop falling on its head (liquid water). With these visual aids, do you think children might remember the three states of matter?

Finally, this book can serve as a clip art collection. Drawings in this book can be photocopied and reproduced for use as bulletin board art, take-home notes, coloring sheets, congratulatory notes, or any purpose you can find.

As you use this book, be aware of all the books, posters, and other paraphernalia that contain cartoons. Look around at all the things you have purchased for your home or classroom that contain cute little cartoon characters. Now, use this book to help your kids create their own visuals and improve their thinking skills as well.

From Classroom Cartooning for the Artistically Challenged, published by Good Year Books. Copyright © 1997 Mike Artell.

Contents

Animals

Hey! Let's learn about . . .

Drawing Animals

In this section, you'll learn lots of ways to draw animals.

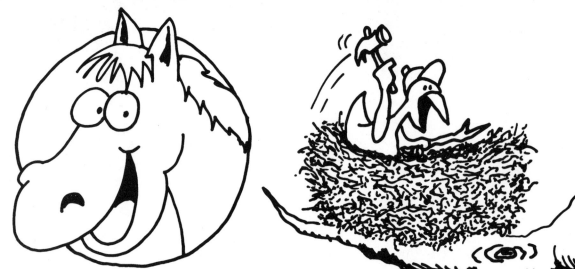

We'll draw horses...

...and birds...

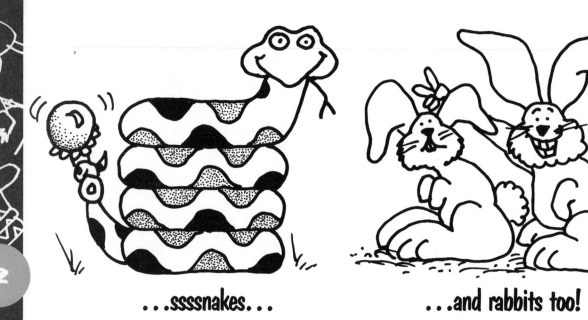

...ssssnakes...

...and rabbits too!

From *Classroom Cartooning for the Artistically Challenged,* published by Good Year Books. Copyright © 1997 Mike Artell.

We'll draw. . . .animals with horns. . .

. . .and animals with claws.

So let's get started!

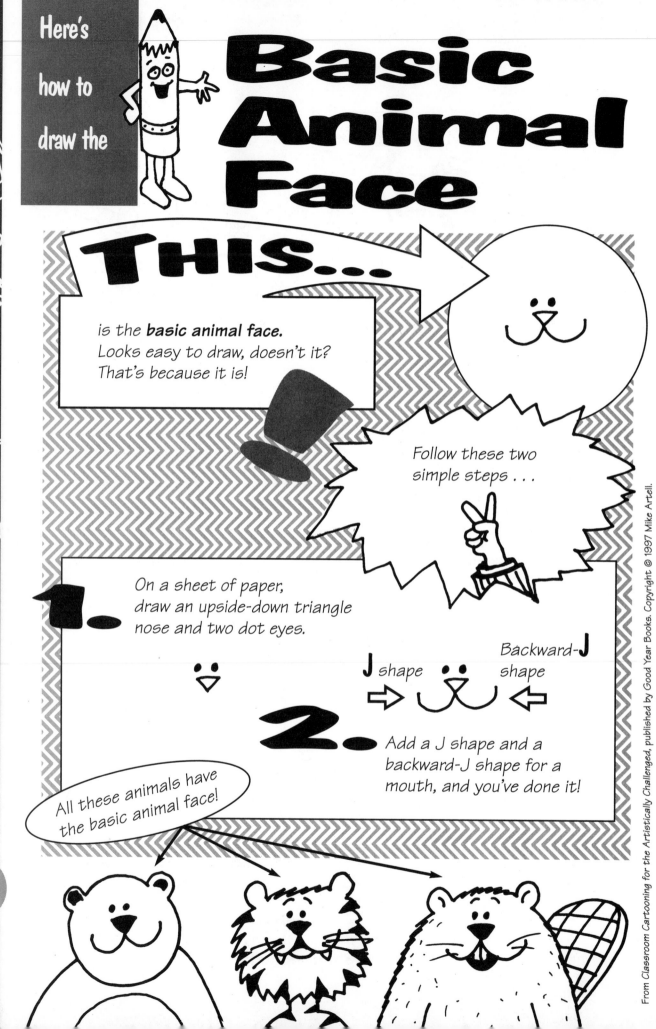

Here's how to draw the

Basic Animal Face

THIS....

is the **basic animal face.**
Looks easy to draw, doesn't it?
That's because it is!

Follow these two simple steps . . .

1. On a sheet of paper, draw an upside-down triangle nose and two dot eyes.

J shape Backward-**J** shape

2. Add a J shape and a backward-J shape for a mouth, and you've done it!

All these animals have the basic animal face!

From *Classroom Cartooning for the Artistically Challenged*, published by Good Year Books. Copyright © 1997 Mike Artell.

4

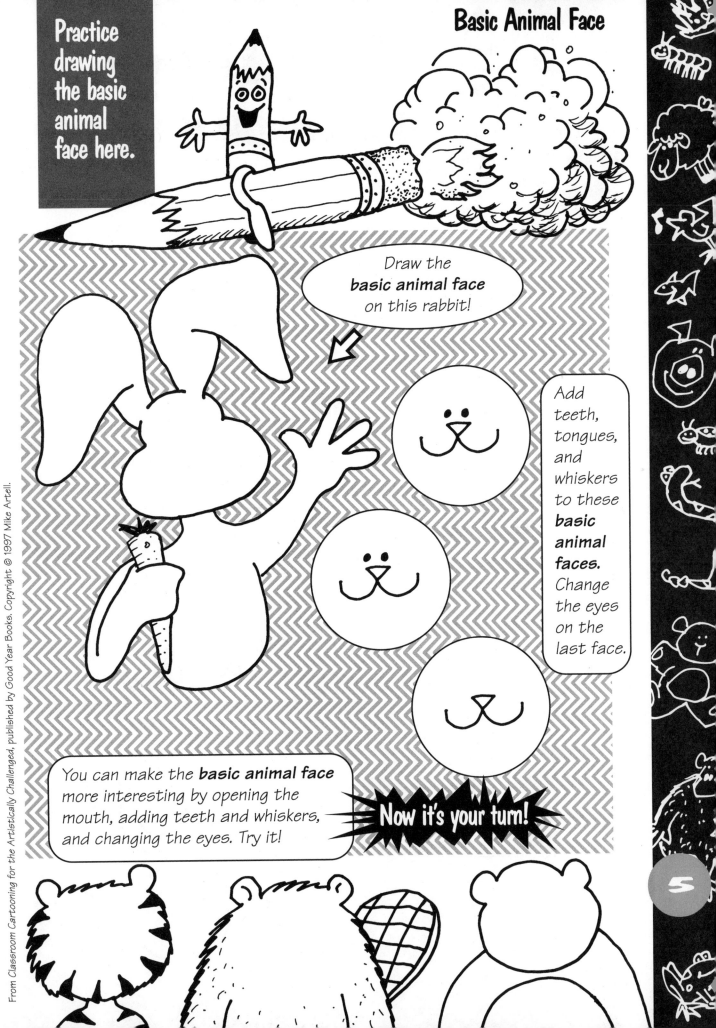

Practice drawing the basic animal face here.

Basic Animal Face

Draw the **basic animal face** on this rabbit!

Add teeth, tongues, and whiskers to these **basic animal faces.** Change the eyes on the last face.

You can make the **basic animal face** more interesting by opening the mouth, adding teeth and whiskers, and changing the eyes. Try it!

Now it's your turn!

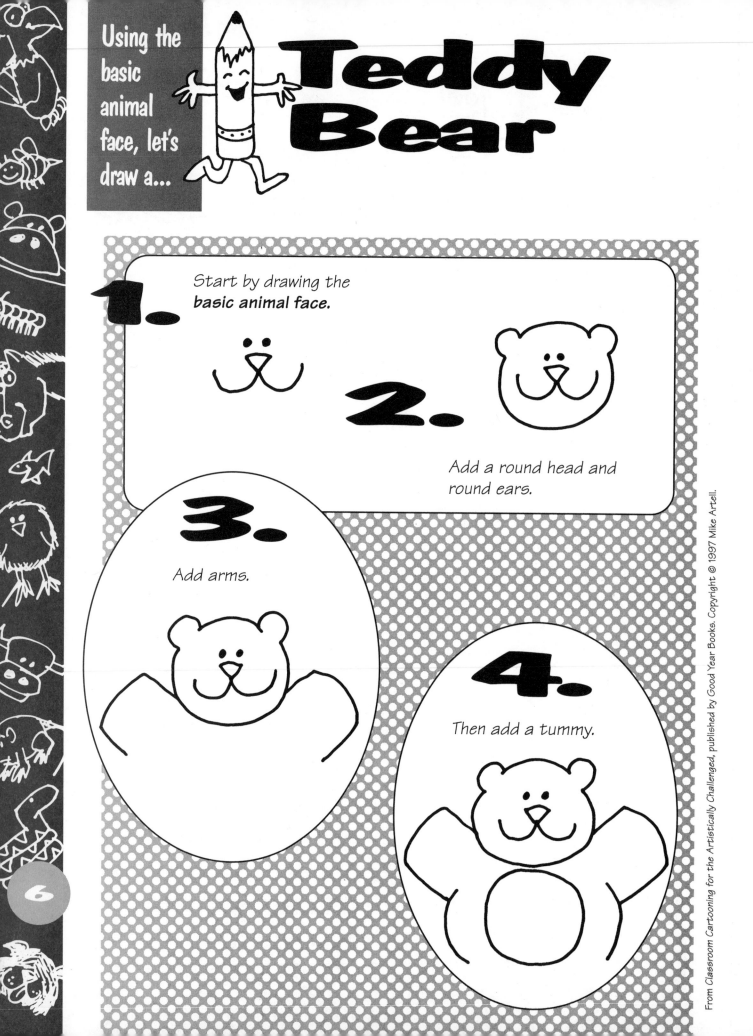

Teddy Bear

1. Start by drawing the **basic animal face.**

2. Add a round head and round ears.

3. Add arms.

4. Then add a tummy.

6

From *Classroom Cartooning for the Artistically Challenged*, published by Good Year Books. Copyright © 1997 Mike Artell.

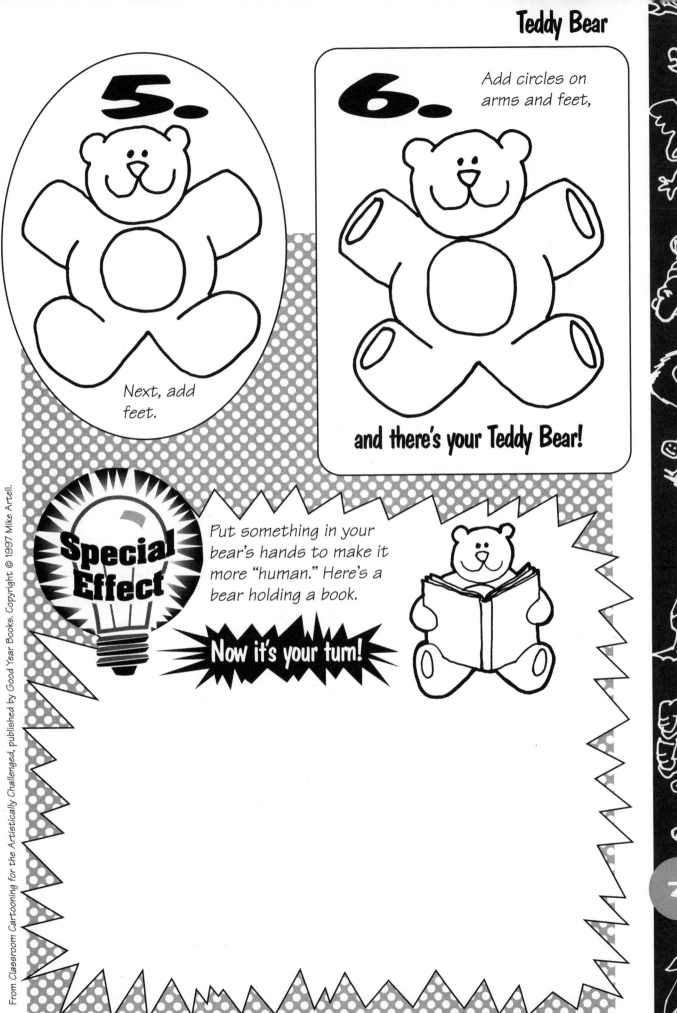

5. Next, add feet.

6. Add circles on arms and feet, and there's your Teddy Bear!

Special Effect

Put something in your bear's hands to make it more "human." Here's a bear holding a book.

Now it's your turn!

7

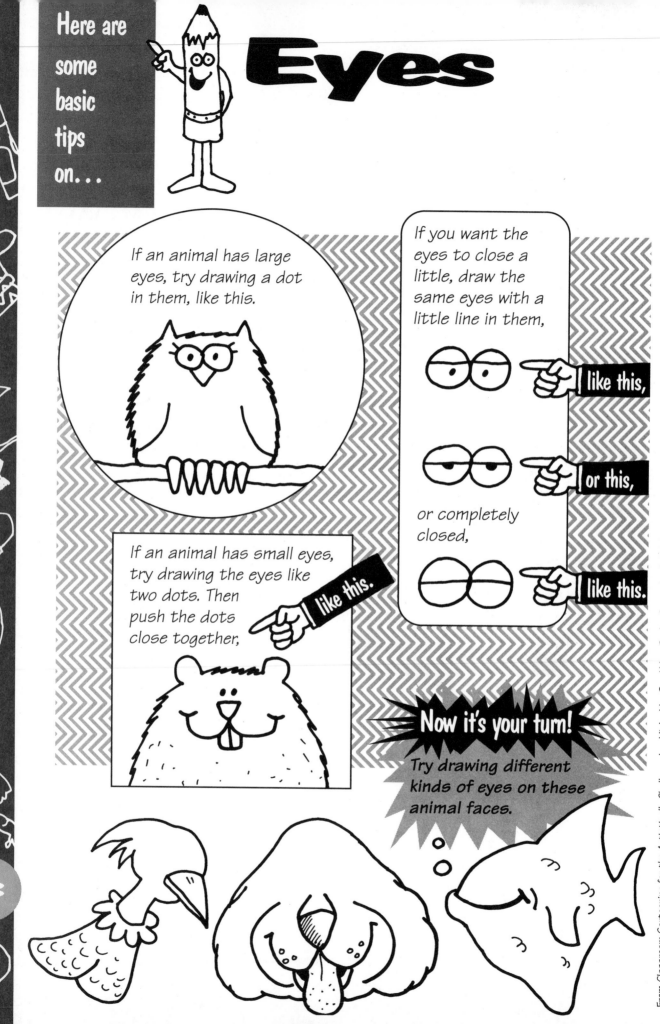

Here are some basic tips on...

Eyes

If an animal has large eyes, try drawing a dot in them, like this.

If you want the eyes to close a little, draw the same eyes with a little line in them, **like this,**

or this,

or completely closed,

like this.

If an animal has small eyes, try drawing the eyes like two dots. Then push the dots close together, **like this.**

Now it's your turn!

Try drawing different kinds of eyes on these animal faces.

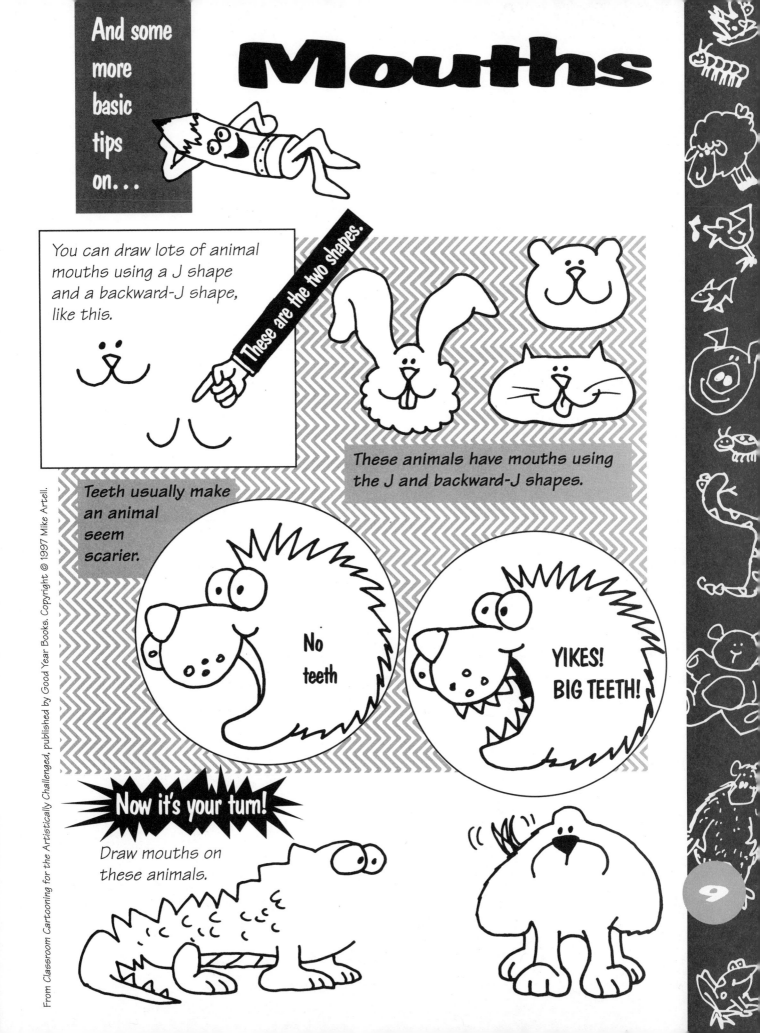

Mouths

And some more basic tips on...

You can draw lots of animal mouths using a J shape and a backward-J shape, like this.

These are the two shapes.

These animals have mouths using the J and backward-J shapes.

Teeth usually make an animal seem scarier.

No teeth

YIKES! BIG TEETH!

Now it's your turn!

Draw mouths on these animals.

Cats

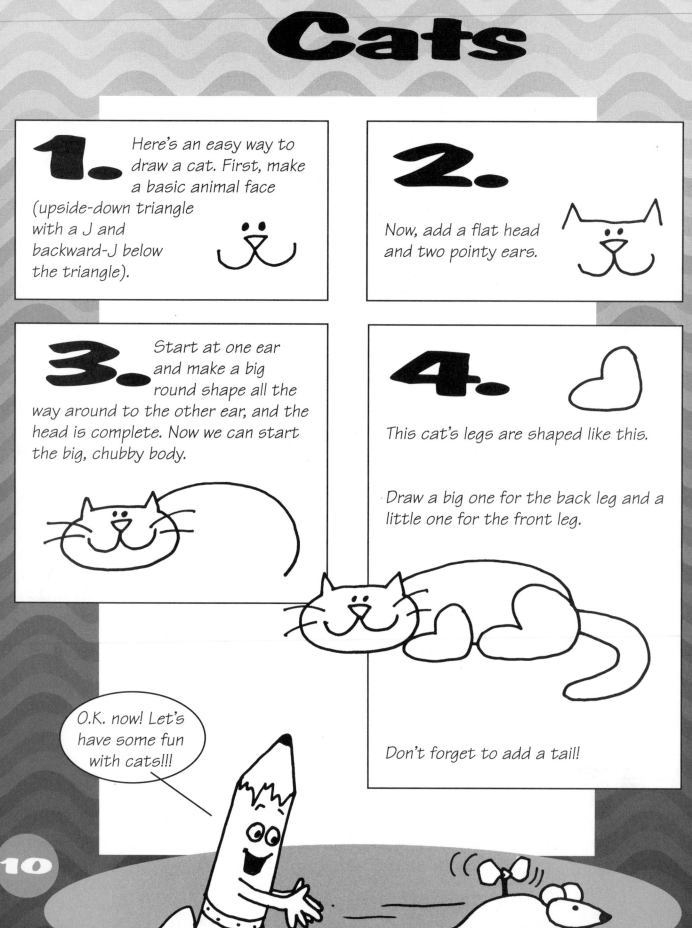

1. Here's an easy way to draw a cat. First, make a basic animal face (upside-down triangle with a J and backward-J below the triangle).

2. Now, add a flat head and two pointy ears.

3. Start at one ear and make a big round shape all the way around to the other ear, and the head is complete. Now we can start the big, chubby body.

4. This cat's legs are shaped like this.

Draw a big one for the back leg and a little one for the front leg.

Don't forget to add a tail!

O.K. now! Let's have some fun with cats!!!

From Classroom Cartooning for the Artistically Challenged, published by Good Year Books. Copyright © 1997 Mike Artell.

This is a fat cat. We can make him look chubby by drawing his face right on his body.

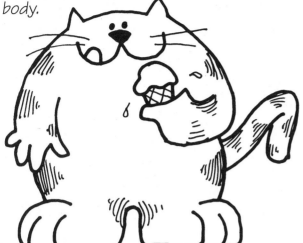

See...his head and his body are all squished together. It helps to put food in his hand too!

This is a cool cat. Notice how his mouth turns down.

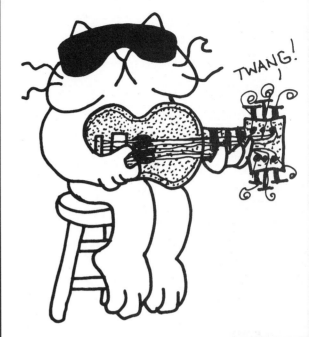

TWANG!

Here are some cats that my friends drew!

Some Things to Try

- Color your cats different ways. Try polka dots, stripes, or checks.

- Draw your cats doing "people" things like driving a car or playing baseball.

- Try drawing your cats' eyes and mouths different sizes. First big, then small.

There's more!

11

Lions

1. First, draw a regular cat's face.

2. Now, add two round ears and a little beard. Then add lots of shaggy hair.

Start at the point of the arrow below and draw lots of big S-shaped hair on the left side of the lion's head. Draw backward-S hair on the right side of the lion's head.

S shapes

Backward-**S** shapes

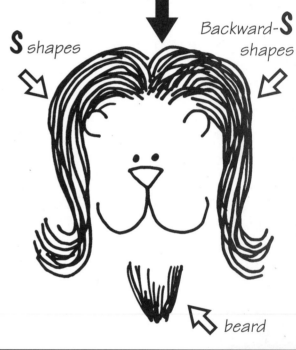

beard

3. Add a crown, some teeth, and some whiskers, and you have the king of beasts, the lion!

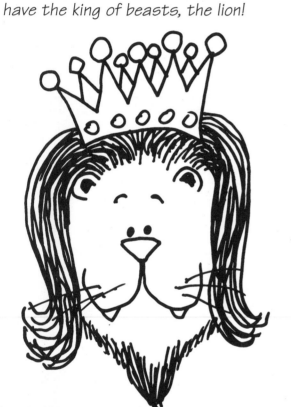

You can also draw the lion's mane like flames.

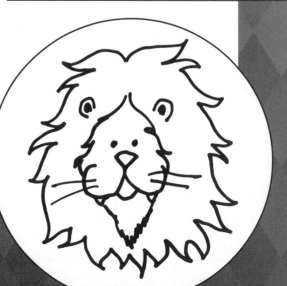

From *Classroom Cartooning for the Artistically Challenged*, published by Good Year Books. Copyright © 1997 Mike Artell.

Give this lion a really unusual hair style.

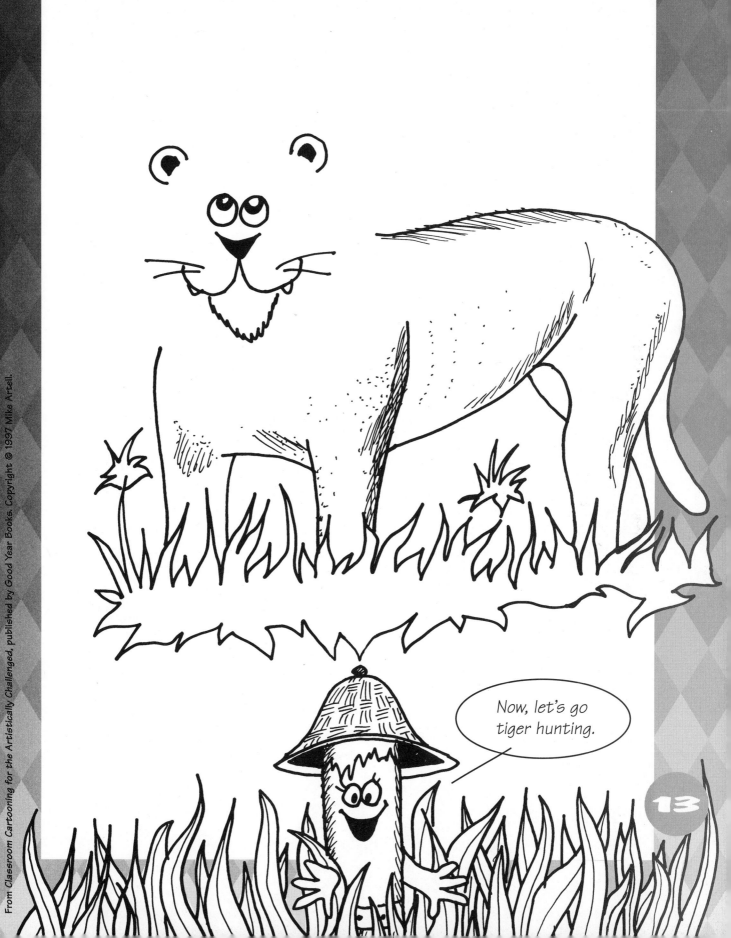

Think Funny!

The word "lion" can give you a lot of funny ideas. First of all, "lion" sounds a lot like "lyin'." You could draw a picture of a lion who doesn't tell the truth and that lion would be a "lyin' lion." If that same lion was lazy and was lying around all day, it would be a "lyin' lyin' lion." If you had a long line of those kind of lions, it would be a "lyin' lyin' lion line." Whew!

Lions are known as the "king of beasts," but what about their kids? Are they the "princes of beasts" and "princesses of beasts"? Could you draw a lion "royal family"?

Lions roar a lot. You might draw a picture of a lion mom saying to her lion children, "How many times must I tell you... SHOUT WHEN YOU TALK!!"

From Classroom Cartooning for the Artistically Challenged, published by Good Year Books. Copyright © 1997 Mike Artell.

1. Start your tiger the same way you started the lion, but add a flat head and rounded ears. Also, add a couple of teeth.

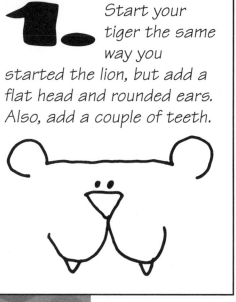

Now it's your turn!

2. Add a happy-face smile and some cloud-shaped fur (like a Santa Claus beard) around the face. Then add whiskers and stripes.

Draw the shaggy hair like a big cloud.

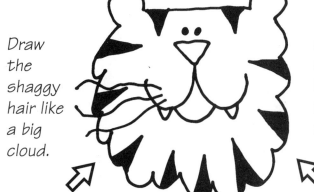

Make the stripes look like little triangles.

15

Draw a picture to go with this poem:

A big yellow tiger named Jay
had frightened his neighbors away.
He had big, sharp teeth
above and beneath,
and he brushed them each
three times a day.

Elephants

1. Elephants are fun to draw. First, draw a small circle for the head and add a big circle for the body. Then add two dot eyes.

2. Add a nose and two floppy ears. Erase the parts of the head where the nose and ears are drawn (where the dotted lines appear in the drawing). Add square feet. Don't forget the tail!

Erase the dotted lines.

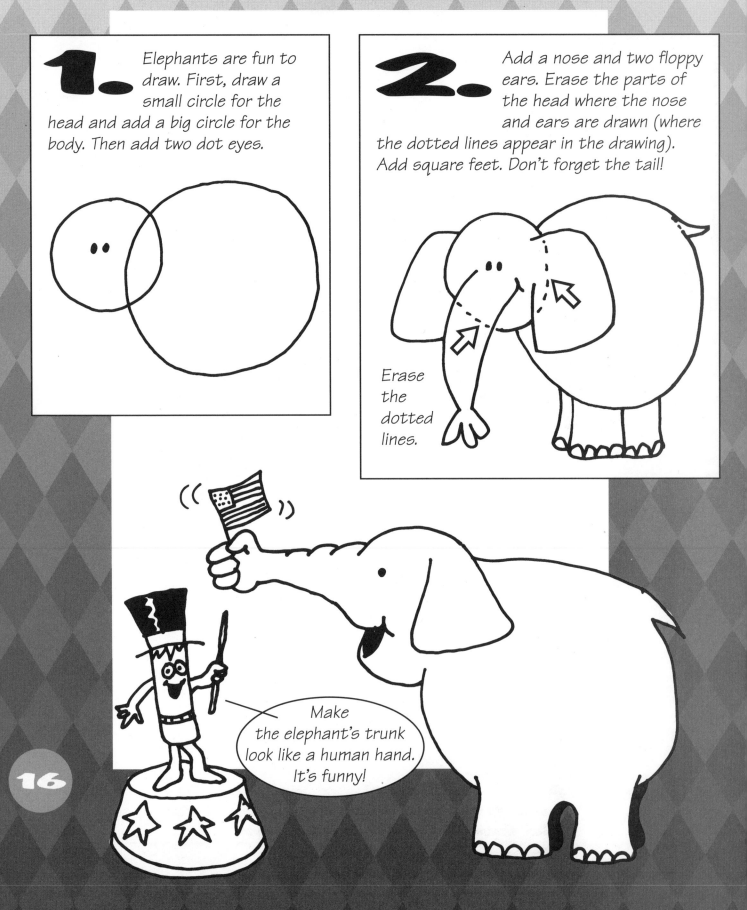

Make the elephant's trunk look like a human hand. It's funny!

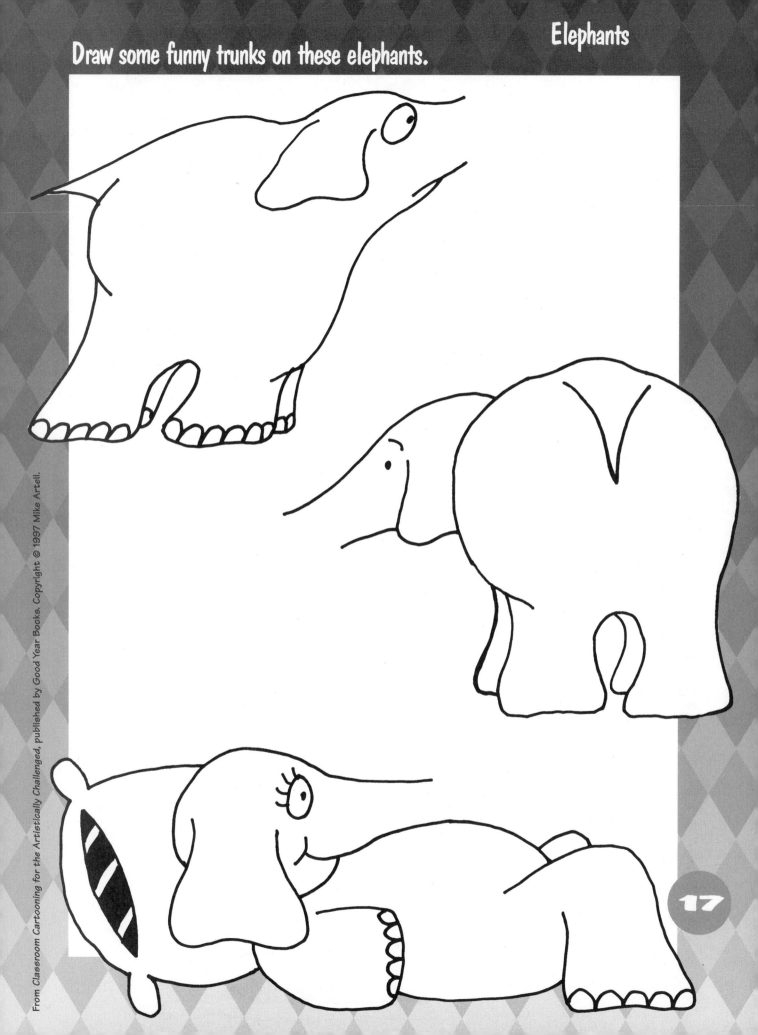

Draw some funny trunks on these elephants.

17

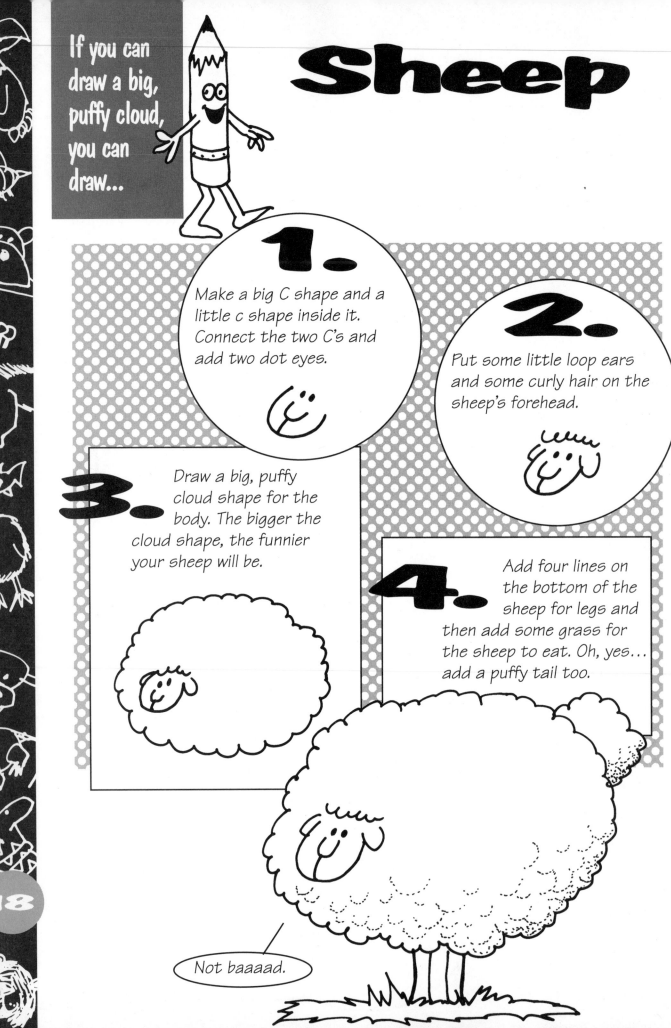

If you can draw a big, puffy cloud, you can draw...

Sheep

1. Make a big C shape and a little c shape inside it. Connect the two C's and add two dot eyes.

2. Put some little loop ears and some curly hair on the sheep's forehead.

3. Draw a big, puffy cloud shape for the body. The bigger the cloud shape, the funnier your sheep will be.

4. Add four lines on the bottom of the sheep for legs and then add some grass for the sheep to eat. Oh, yes... add a puffy tail too.

Not baaaad.

Think Funny!

If you want to draw funny pictures, you have to think funny! Just for a moment, stop drawing and think about different animals and what makes each one special. Elephants have a long nose, big ears, and a chubby body. Giraffes have long, skinny necks. Sharks, lions, and tigers have lots of sharp teeth. Zebras have stripes.

Let's think funny! Exaggerate each animal's special feature. Draw an elephant with a nose so long it looks like a garden hose. Better yet...draw an elephant with a tiny nose. Does the animal have a lot of teeth? Good! Draw some braces on it. Draw it at the dentist's office. Draw the animal without any teeth. Draw it with a few teeth missing. Remember... think funny!

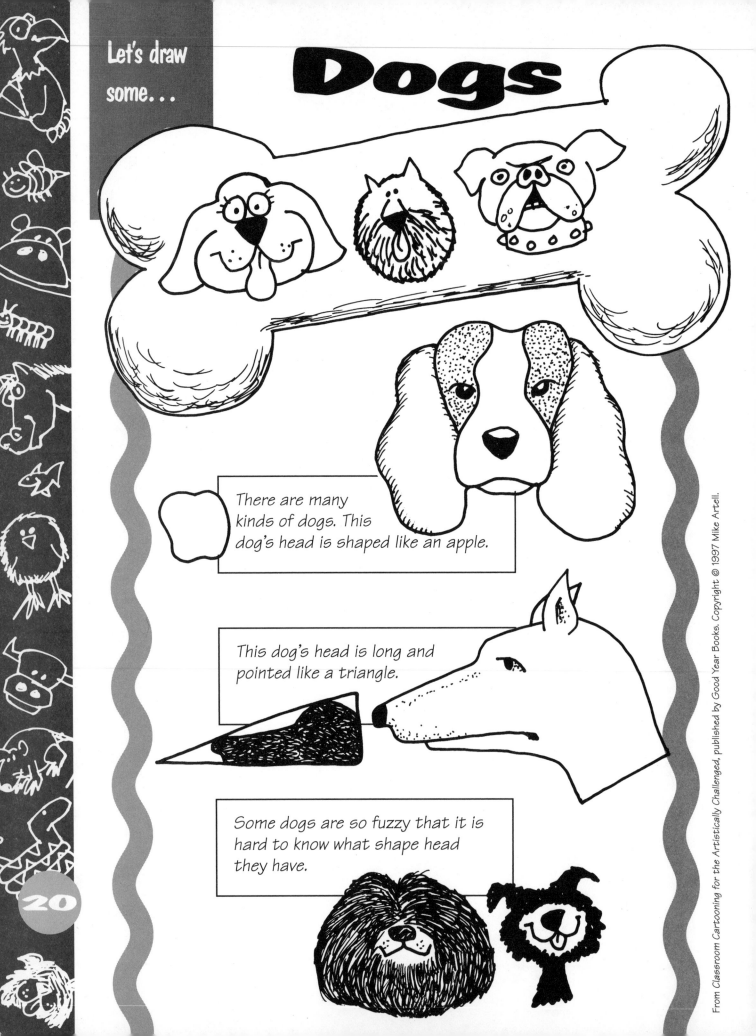

Let's draw some...

Dogs

There are many kinds of dogs. This dog's head is shaped like an apple.

This dog's head is long and pointed like a triangle.

Some dogs are so fuzzy that it is hard to know what shape head they have.

20

From *Classroom Cartooning for the Artistically Challenged*, published by Good Year Books. Copyright © 1997 Mike Artell.

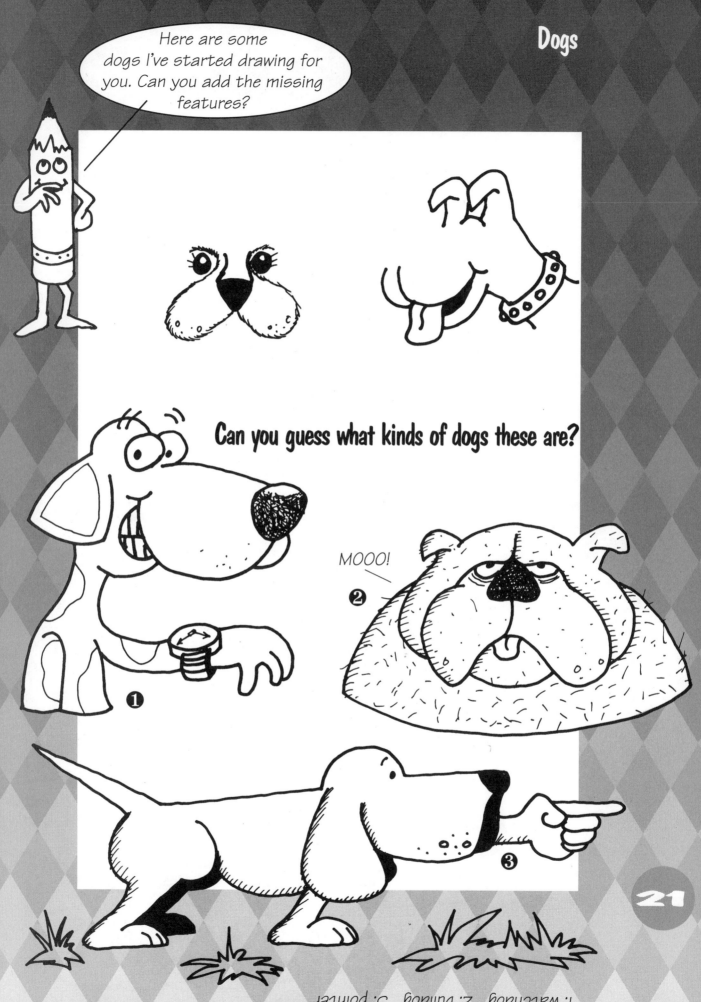

21

1. watchdog 2. bulldog 3. pointer

Pigs

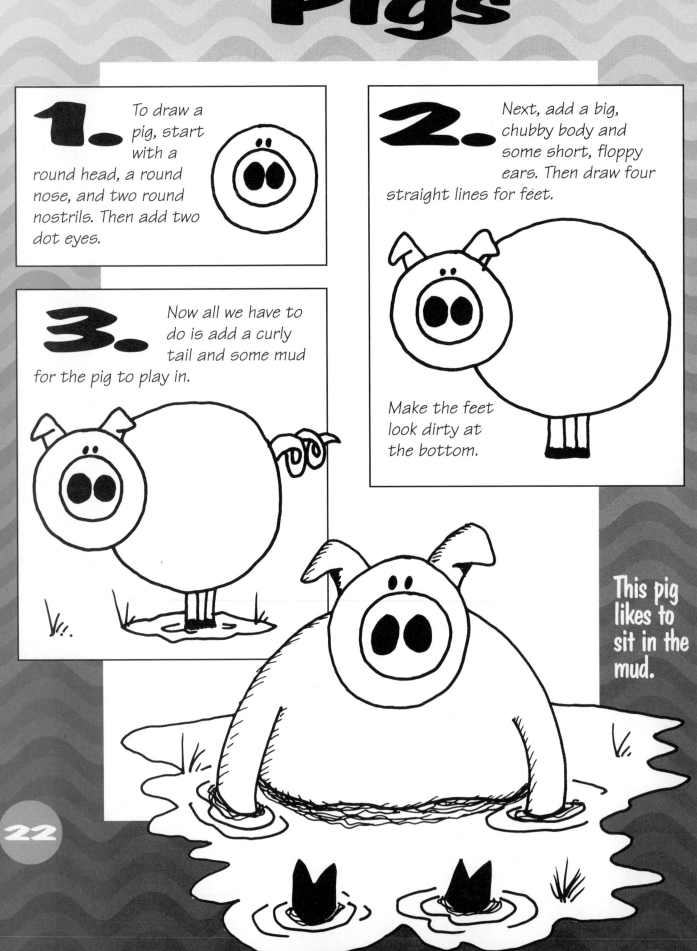

1. To draw a pig, start with a round head, a round nose, and two round nostrils. Then add two dot eyes.

2. Next, add a big, chubby body and some short, floppy ears. Then draw four straight lines for feet.

Make the feet look dirty at the bottom.

3. Now all we have to do is add a curly tail and some mud for the pig to play in.

This pig likes to sit in the mud.

Pork Chop

Deviled Ham

Sweet and Sour Pork

Hogwash

Can you draw some "pigtures" to go with these pig expressions?

23

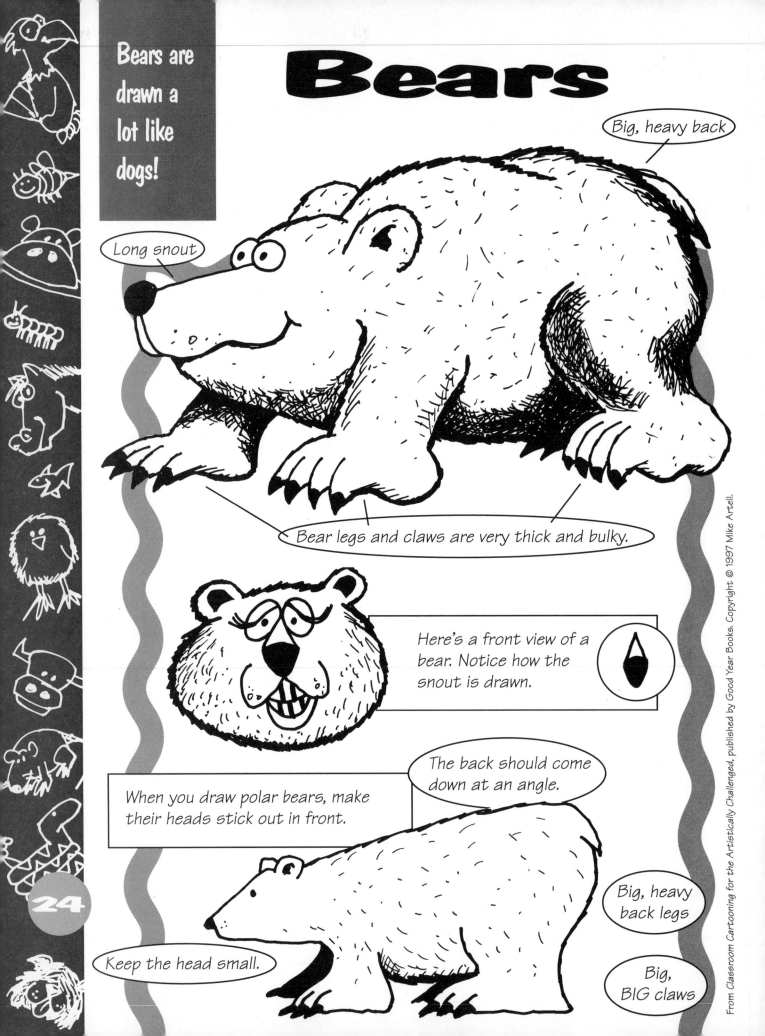

Bears

Bears are drawn a lot like dogs!

Big, heavy back

Long snout

Bear legs and claws are very thick and bulky.

Here's a front view of a bear. Notice how the snout is drawn.

The back should come down at an angle.

When you draw polar bears, make their heads stick out in front.

Big, heavy back legs

Keep the head small.

Big, BIG claws

Here's a close-up drawing of a bear getting ready to eat some honey. Notice how his eyes bulge at the thought of something good to eat. Also, his mouth is smiling and he's drooling just a bit (yuck!).

Now it's your turn!

Draw another picture of a bear about to eat something. It can be funny or scary...whatever you want!

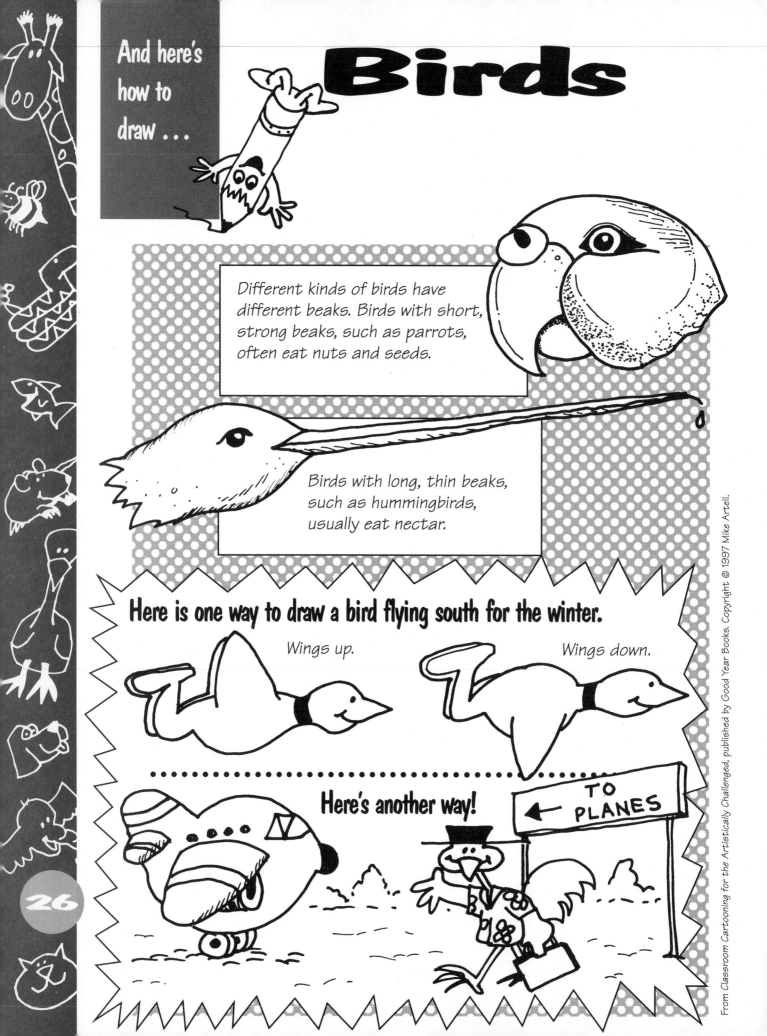

And here's how to draw ...

Birds

Different kinds of birds have different beaks. Birds with short, strong beaks, such as parrots, often eat nuts and seeds.

Birds with long, thin beaks, such as hummingbirds, usually eat nectar.

Here is one way to draw a bird flying south for the winter.

Wings up.

Wings down.

Here's another way!

TO PLANES

From Classroom Cartooning for the Artistically Challenged, published by Good Year Books. Copyright © 1997 Mike Artell.

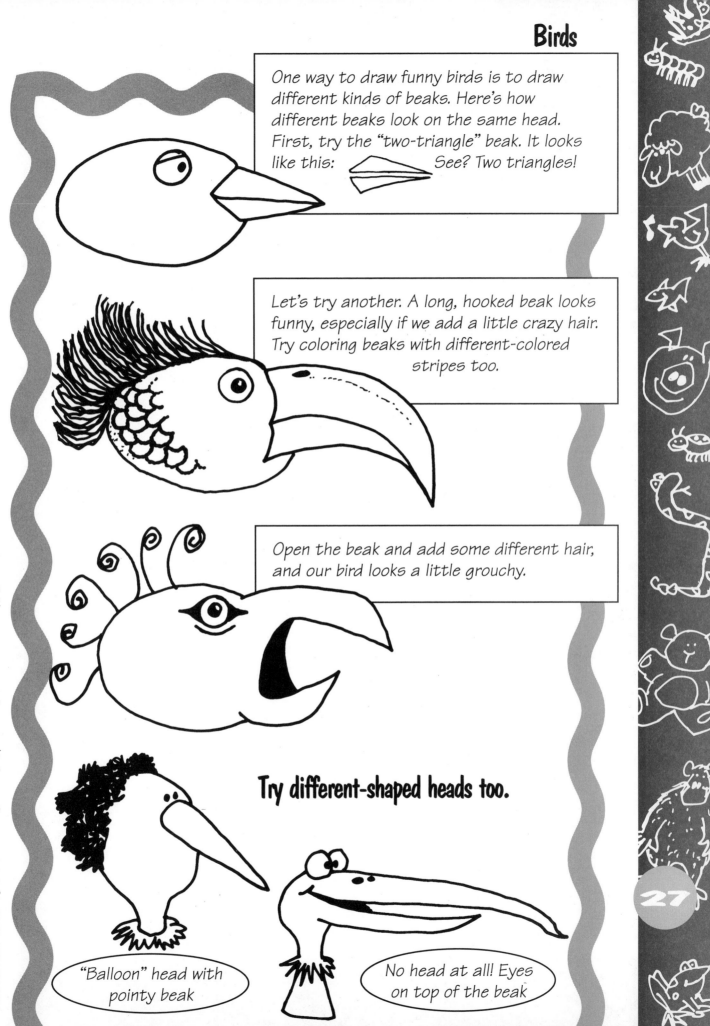

Birds

One way to draw funny birds is to draw different kinds of beaks. Here's how different beaks look on the same head. First, try the "two-triangle" beak. It looks like this: See? Two triangles!

Let's try another. A long, hooked beak looks funny, especially if we add a little crazy hair. Try coloring beaks with different-colored stripes too.

Open the beak and add some different hair, and our bird looks a little grouchy.

Try different-shaped heads too.

"Balloon" head with pointy beak

No head at all! Eyes on top of the beak

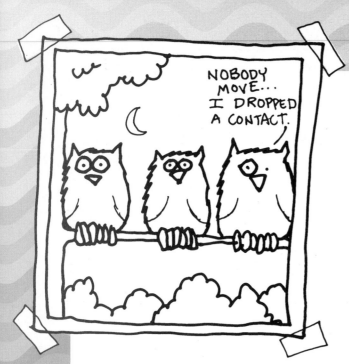

Try This!

• Put big beaks, long necks, and long legs on your birds. They're almost always funnier this way.

• Try using different colors on the top half of your birds while leaving the bottom half white.

• Don't draw the legs of the bird. Instead, draw grass, water, or even eggs beneath the bird.

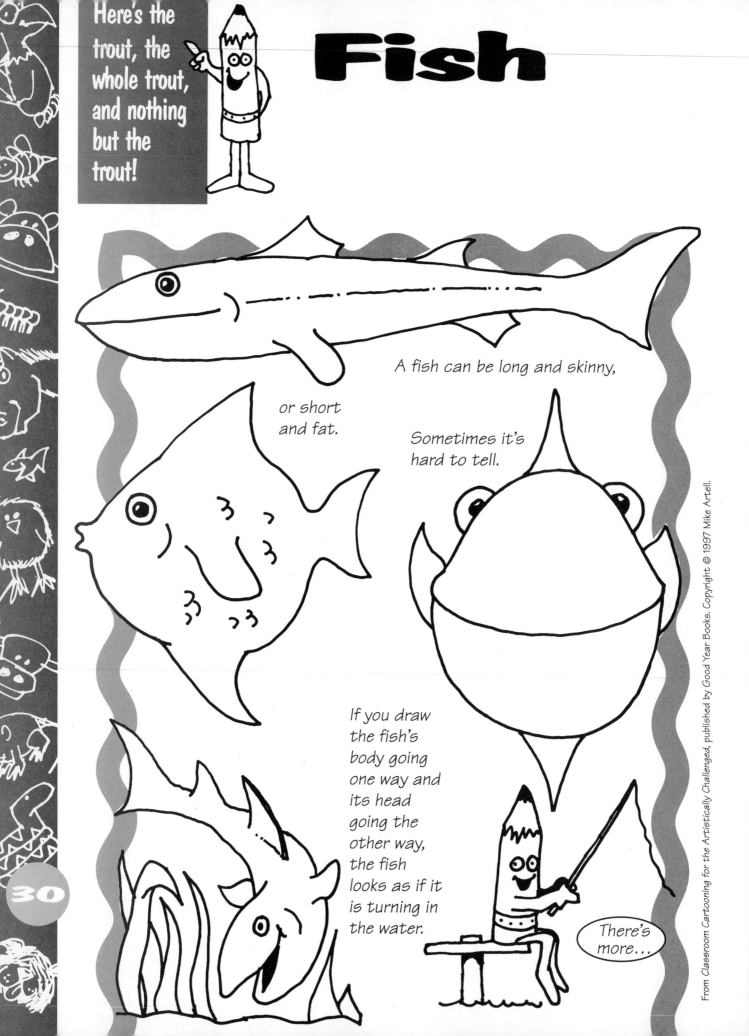

Fish

A fish can be long and skinny,

or short and fat.

Sometimes it's hard to tell.

If you draw the fish's body going one way and its head going the other way, the fish looks as if it is turning in the water.

There's more...

From Classroom Cartooning for the Artistically Challenged, published by Good Year Books. Copyright © 1997 Mike Artell.

Try adding some details and special effects to your fish.

This fish looks plain.

Add some scales and a few bubbles, and you've drawn a much better picture.

Draw just the head of the fish sticking out of the water.

You can't catch me!

Sharks don't have eyebrows, but you can add them to make the shark look meaner.

Draw sharp, pointy teeth on sharks.

Ideas!

- Fish travel in "schools." Draw a funny picture of a fish at "school."
- Draw a "flying" fish.
- Draw a "cat" fish. (Meow!)
- Tropical fish are known for their bright colors. Draw and color a big, bright tropical fish.

Unscramble these fish names
1. HRAKS
2. ATGSIYNR
3. NOSLAM

Answers: 1. shark 2. stingray 3. salmon

31

Fish

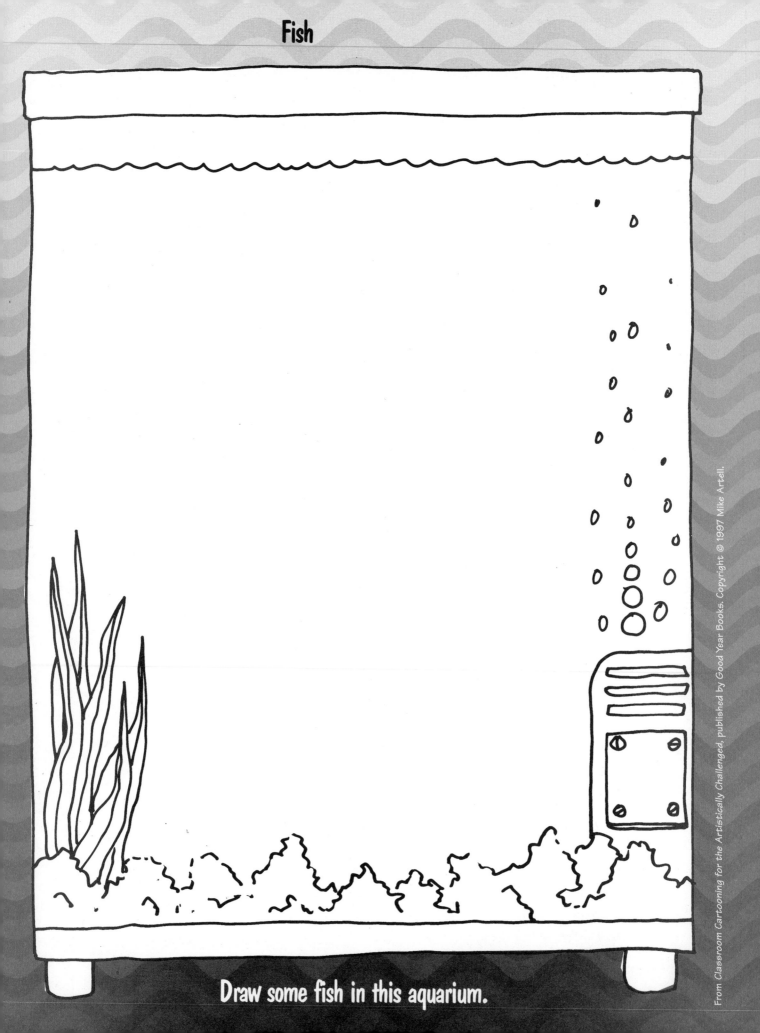

Draw some fish in this aquarium.

Think Funny!

Think about animal sounds. Mice squeak, lions and tigers roar, birds tweet, snakes hiss. What if animals tried to learn each other's languages so they could talk to each other? Draw a picture or write a story that involves an animal speaking another animal's language.

In the animal world, colors are very important. Flamingos are bright pink, zebras are black and white, baby chicks are yellow, baby deer are spotted, and parrots are a mixture of colors.

Try drawing animals and giving them unusual colors.

Here's another idea. Remember that humans become red-faced when they get angry or embarrassed. When we hold our breath, we turn blue, and when we're sick, we look a little green. Draw some animals who are experiencing some of these same "color changes."

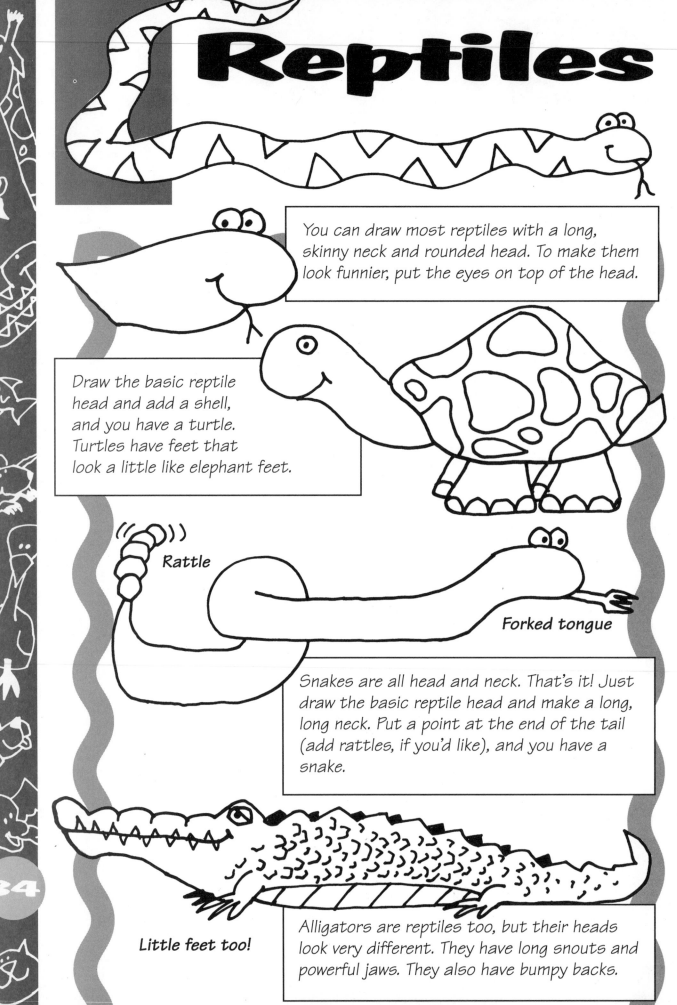

Reptiles

You can draw most reptiles with a long, skinny neck and rounded head. To make them look funnier, put the eyes on top of the head.

Draw the basic reptile head and add a shell, and you have a turtle. Turtles have feet that look a little like elephant feet.

Rattle

Forked tongue

Snakes are all head and neck. That's it! Just draw the basic reptile head and make a long, long neck. Put a point at the end of the tail (add rattles, if you'd like), and you have a snake.

Little feet too!

Alligators are reptiles too, but their heads look very different. They have long snouts and powerful jaws. They also have bumpy backs.

34

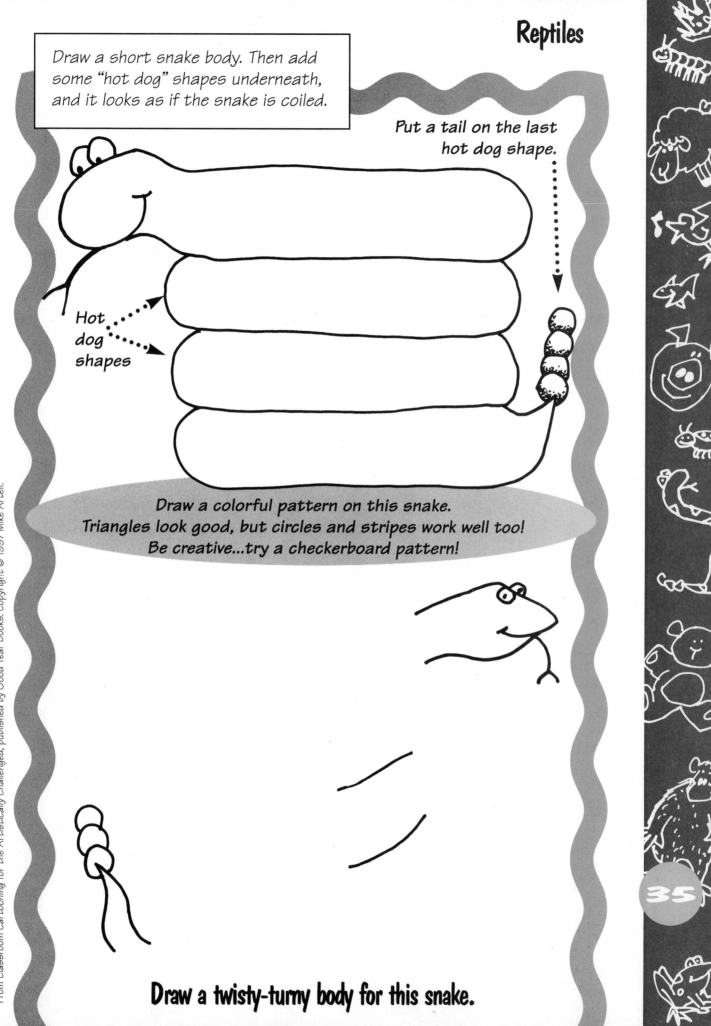

Reptiles

Draw a short snake body. Then add some "hot dog" shapes underneath, and it looks as if the snake is coiled.

Put a tail on the last hot dog shape.

Hot dog shapes

Draw a colorful pattern on this snake.
Triangles look good, but circles and stripes work well too!
Be creative...try a checkerboard pattern!

Draw a twisty-turny body for this snake.

Rabbits

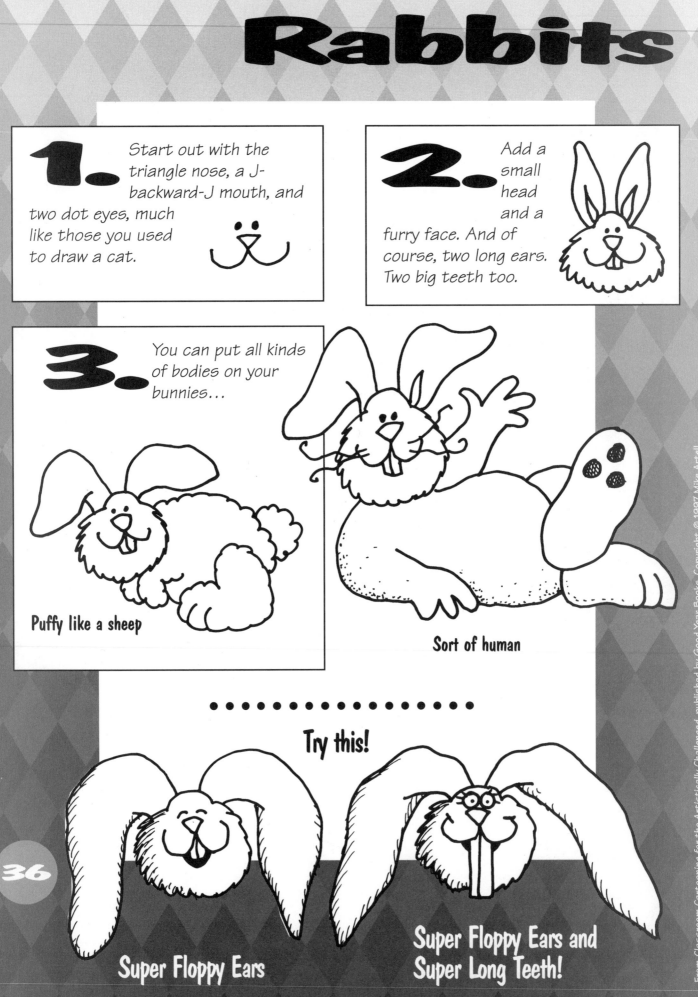

1. Start out with the triangle nose, a J-backward-J mouth, and two dot eyes, much like those you used to draw a cat.

2. Add a small head and a furry face. And of course, two long ears. Two big teeth too.

3. You can put all kinds of bodies on your bunnies...

Puffy like a sheep

Sort of human

Try this!

Super Floppy Ears

Super Floppy Ears and Super Long Teeth!

36

From Classroom Cartooning for the Artistically Challenged, published by Good Year Books. Copyright © 1997 Mike Artell.

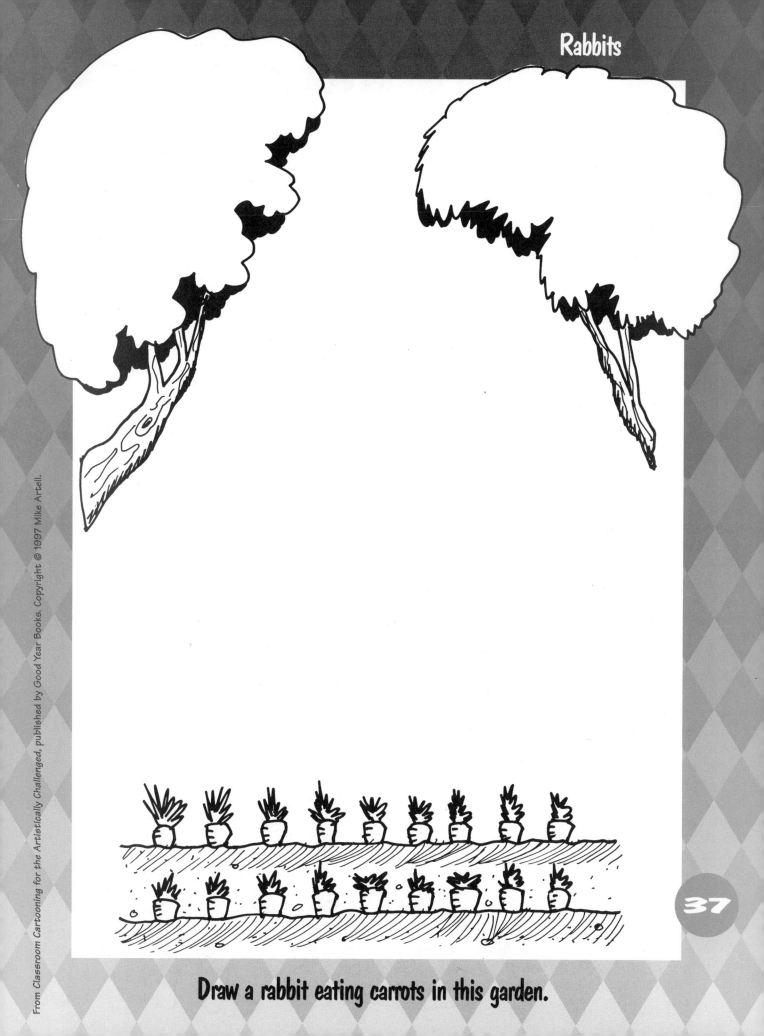

37

Draw a rabbit eating carrots in this garden.

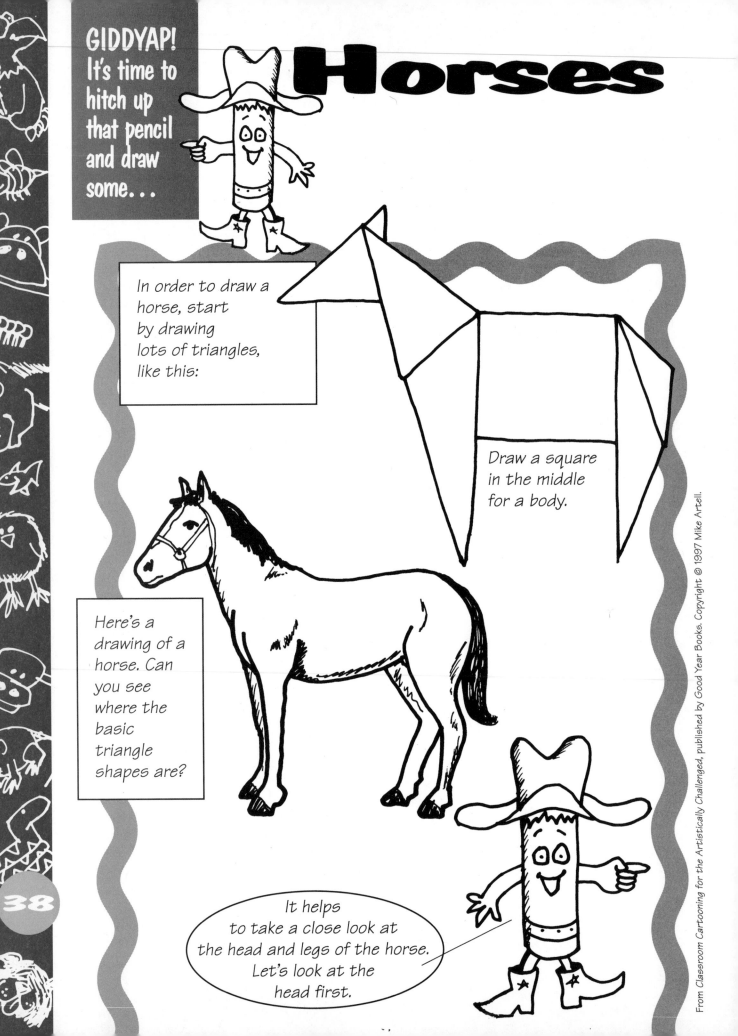

Horses

In order to draw a horse, start by drawing lots of triangles, like this:

Draw a square in the middle for a body.

Here's a drawing of a horse. Can you see where the basic triangle shapes are?

It helps to take a close look at the head and legs of the horse. Let's look at the head first.

38

Horse Heads

The horse's head is basically a triangle shape. If you start with a triangle, you can add features such as the nose and mouth, and you can "round" the edges of the triangle.

The same thing goes for the front view of the horse. Start with a triangle. Then begin "rounding" the edges and adding details.

Now it's your turn!
Try it on another piece of paper.

The horse's back leg can be a little tricky to draw because it bends backwards.

1. Here's a tip that may help you:

Draw the front part of the leg like this. Notice that there is very little "curvy-ness" in this part of the leg.

2. Now, draw the back part of the leg like this:

There are LOTS of curves in this part.

3. Now put the two drawings together. Add a little bump and another curve to the back. And add a hoof.

Now let's look at some baby horses.

The bodies of baby horses, or colts, are not as long as the bodies of adult horses. This is true for almost all animals. When you draw colts, make the bodies a little shorter. The legs on most colts usually look too long and skinny for their bodies.

But the legs on workhorses and farm horses are thick and short. When you draw these kinds of colts, keep the bodies short and draw the heads a little larger.

41

If you like to draw cartoons, your horses are going to look a lot funnier!
To draw cartoon horses, try these tips:

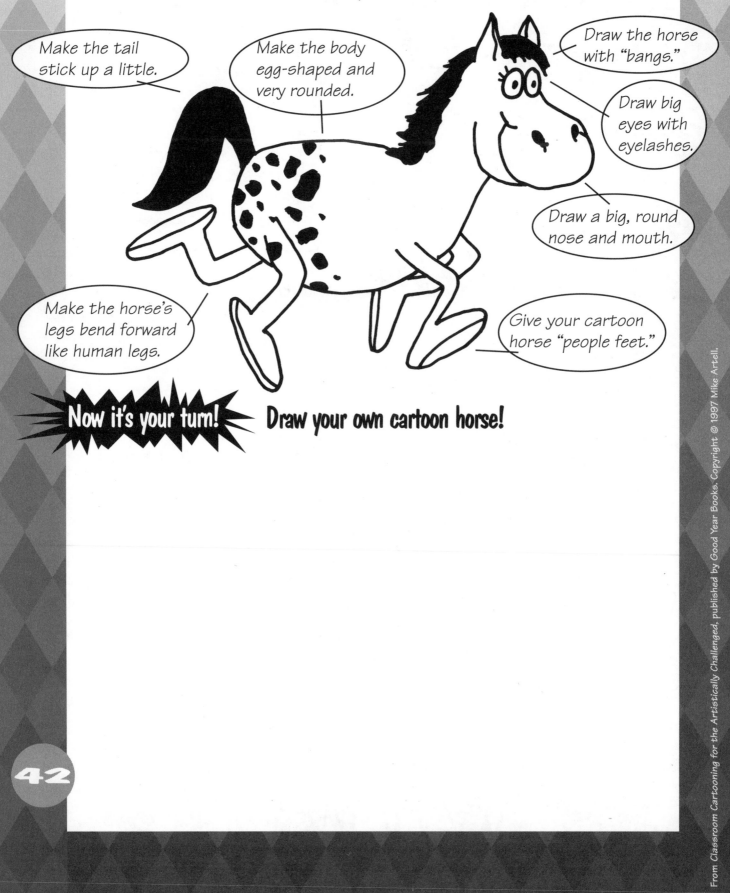

Make the tail stick up a little.

Make the body egg-shaped and very rounded.

Draw the horse with "bangs."

Draw big eyes with eyelashes.

Draw a big, round nose and mouth.

Make the horse's legs bend forward like human legs.

Give your cartoon horse "people feet."

Now it's your turn! Draw your own cartoon horse!

Think Funny!

Sometimes animal names can give you a funny idea. Think about the name "sea horse." A real sea horse is an animal that lives underwater. But what if we put a racehorse or a pony on a boat in a sailor's uniform? That would be a "sea horse" too! Get it?

How about a "sea lion"? a "bald eagle"? a "butterfly"? a "bat"? a "pack rat"? a "homing pigeon"?

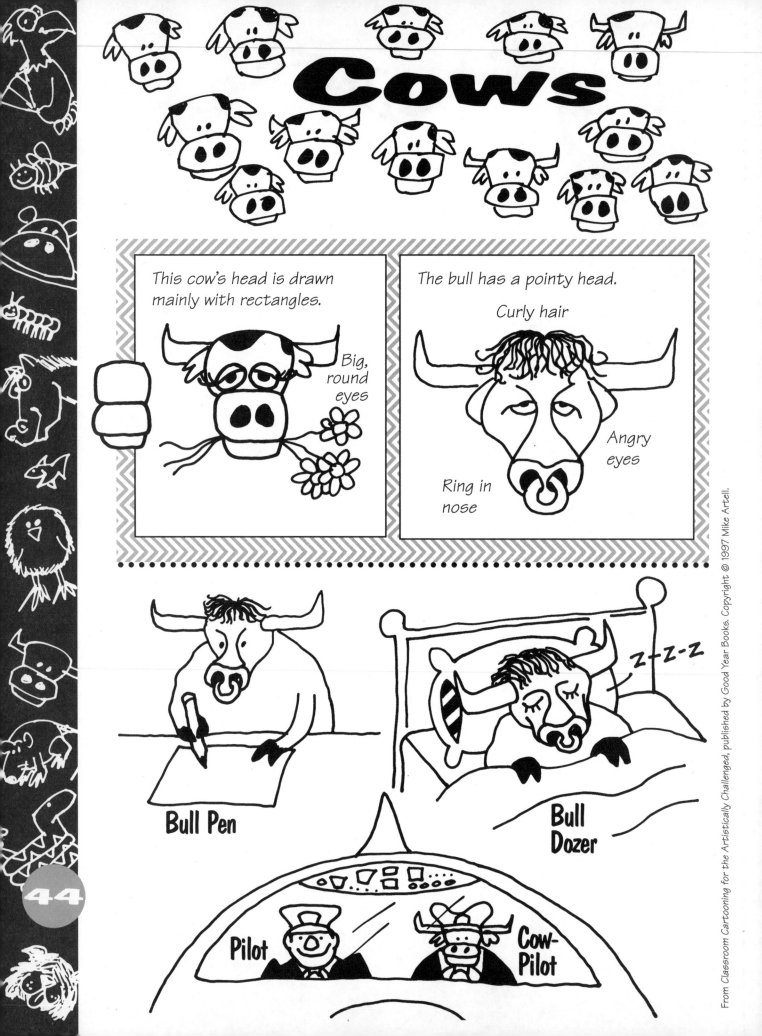

Cows

This cow's head is drawn mainly with rectangles.

Big, round eyes

The bull has a pointy head.

Curly hair

Angry eyes

Ring in nose

Bull Pen

Bull Dozer

Z-Z-Z

Pilot

Cow-Pilot

Now it's your turn! First, color this cow, then try drawing your own cow in the picture frame at the bottom of this page!

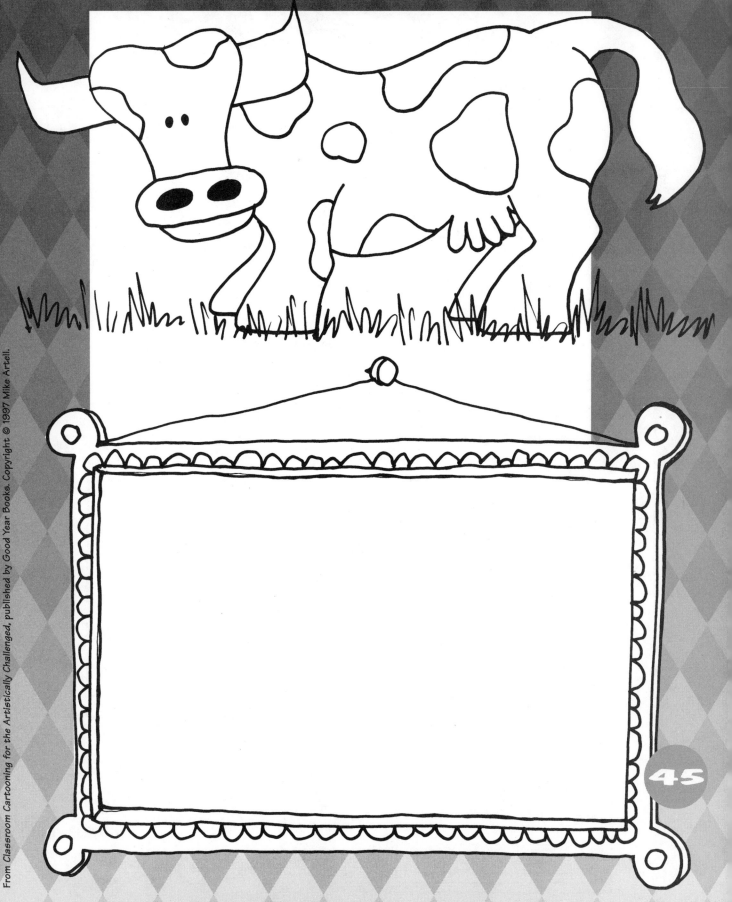

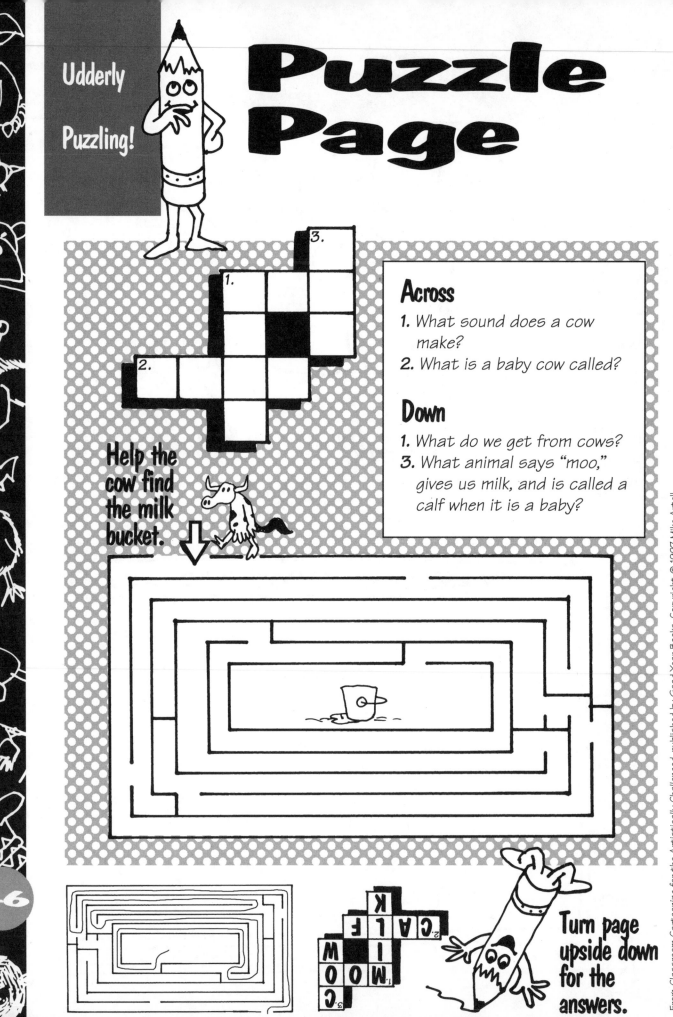

Puzzle Page

Udderly Puzzling!

Across

1. What sound does a cow make?
2. What is a baby cow called?

Down

1. What do we get from cows?
3. What animal says "moo," gives us milk, and is called a calf when it is a baby?

Help the cow find the milk bucket.

Turn page upside down for the answers.

From *Classroom Cartooning for the Artistically Challenged*, published by Good Year Books. Copyright © 1997 Mike Artell.

Think Funny!

Try this:

Cows say "moo." Draw a funny cartoon based on one of these words that starts with a "moo" sound:

mood, moon, moose, move, movie, moving

Or try this:

Finish this limerick and draw a cartoon to go with it:

There was an old cow they called Lou

who did things that most cows couldn't do.

But strangest of all,

when her cow friends would call,

old Lou...

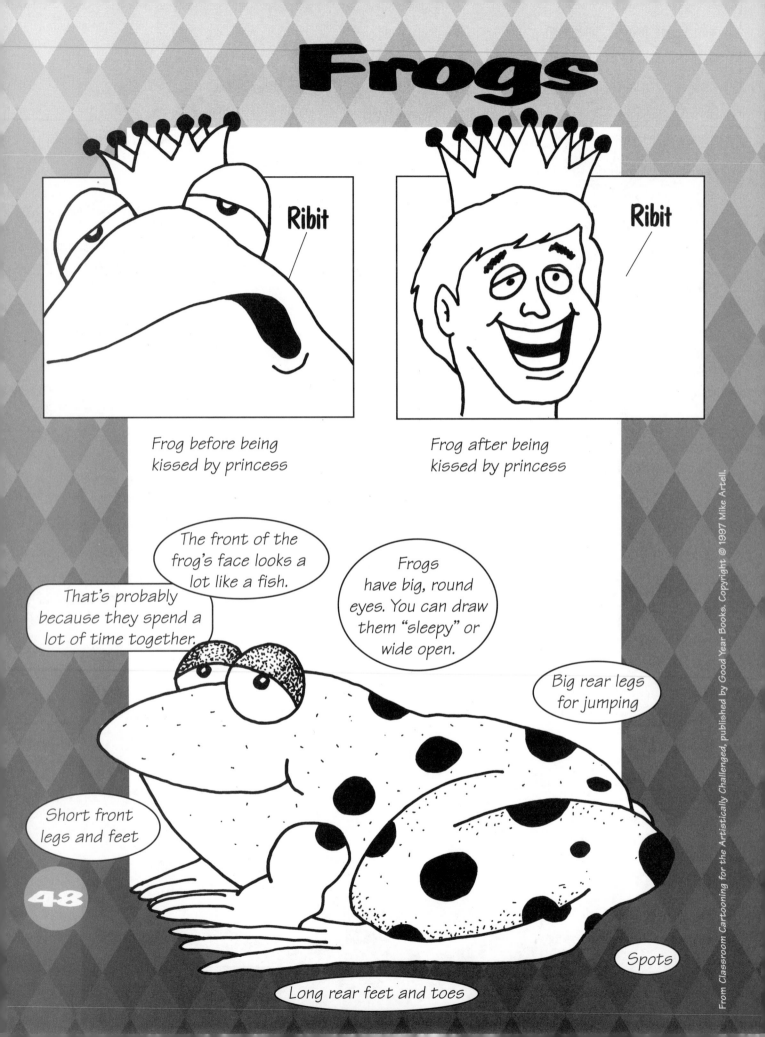

Frogs

Ribit

Ribit

Frog before being kissed by princess

Frog after being kissed by princess

The front of the frog's face looks a lot like a fish.

That's probably because they spend a lot of time together.

Frogs have big, round eyes. You can draw them "sleepy" or wide open.

Big rear legs for jumping

Short front legs and feet

Spots

Long rear feet and toes

48

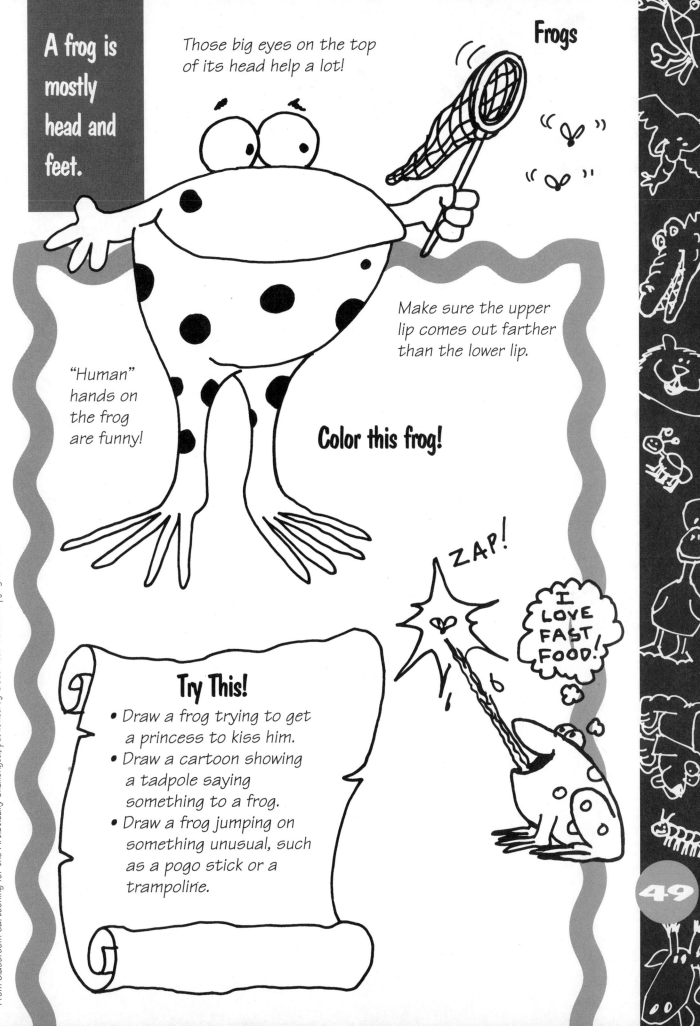

A frog is mostly head and feet.

Those big eyes on the top of its head help a lot!

Frogs

Make sure the upper lip comes out farther than the lower lip.

"Human" hands on the frog are funny!

Color this frog!

ZAP!

I LOVE FAST FOOD!

Try This!

- Draw a frog trying to get a princess to kiss him.
- Draw a cartoon showing a tadpole saying something to a frog.
- Draw a frog jumping on something unusual, such as a pogo stick or a trampoline.

49

Think Funny!

Opposites can be lots of fun! Imagine a polar bear who likes warm weather and hates cold weather. Think about a pig who has nice table manners and is not messy at all.

Wouldn't it be funny to meet a homing pigeon who keeps getting lost? An eagle with bad eyesight? a lazy beaver? A mountain goat that keeps slipping? Try thinking about funny opposites.

50

From Classroom Cartooning for the Artistically Challenged, published by Good Year Books. Copyright © 1997 Mike Artell.

Textures

Let's try some textures next. Place different materials under this page. Then rub a crayon or marker over the drawings. Try using sandpaper or different kinds of cloth...even the sidewalk!

Here are some I did!

51

Think Funny!

One way to make your animal drawings funnier is to draw your animals doing "people" things. For instance, ducks like to swim, and so do most humans. Humans wear swimsuits, ducks don't. Draw a duck doing what a human would do, wearing a swimsuit. Skunks don't smell very good. What do people do when they don't smell good? take a shower?

put on deodorant or perfume? Draw a skunk doing what a human would do.

Humans love to play games: soccer, basketball, football, tennis. Draw some animals playing games. Giraffes might be good at basketball because their necks are so long. Monkeys would be good at gymnastics. Beavers could play tennis with their tails. Draw one or more animals doing "people" things.

52

From Classroom Cartooning for the Artistically Challenged, published by Good Year Books. Copyright © 1997 Mike Artell.

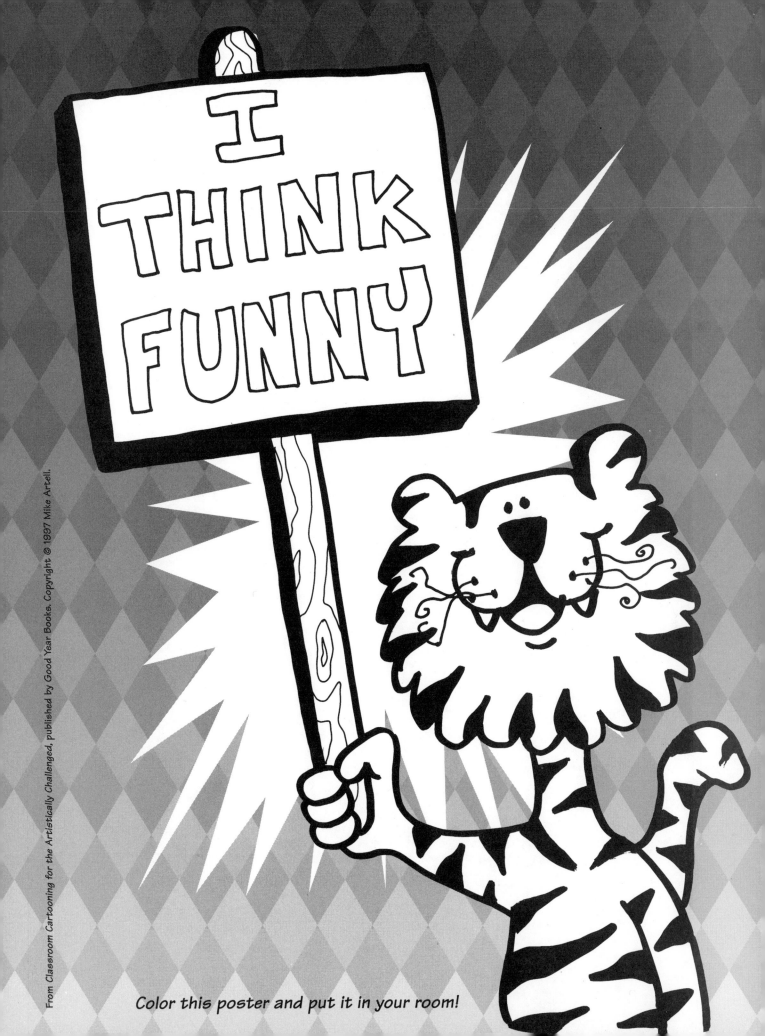

Color this poster and put it in your room!

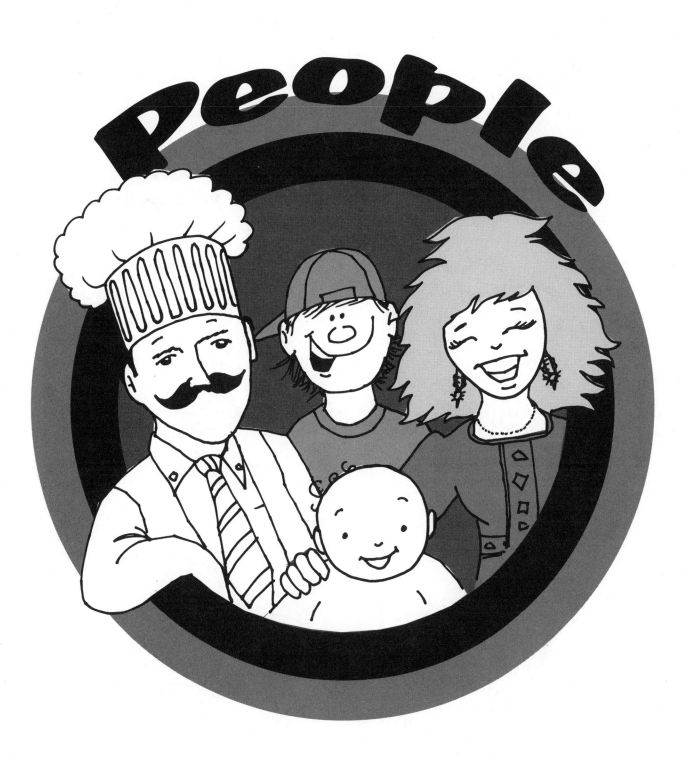

Drawing People

In this section, you'll learn lots of ways to draw people.

You'll learn to draw happy people,

people doing silly things,

people with unusual faces,

and people in motion.

You'll also get some ideas for drawing...

hands,

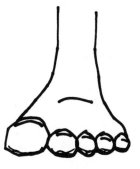

feet,

and unusual bodies.

So, let's get started!

Faces

On a normal human face, the eyes are about halfway between the top of the head and the chin. The bottom of the nose is about halfway between the eyes and the chin.

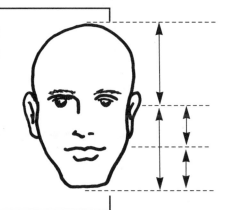

On a cartoon face, things get squished together and pulled apart. You can make some facial features larger and others smaller.

On this face, the **eyes** are two little dots drawn close together. The **nose** is a big ball drawn close to the top of the head. The **mouth** is a little hill or rainbow.

On this face, the **eyes** are little rainbows and the **nose** is a bump. Notice the big, smiley-face **mouth**.

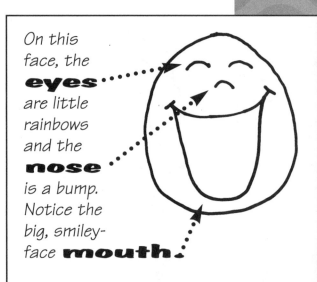

Now it's your turn!

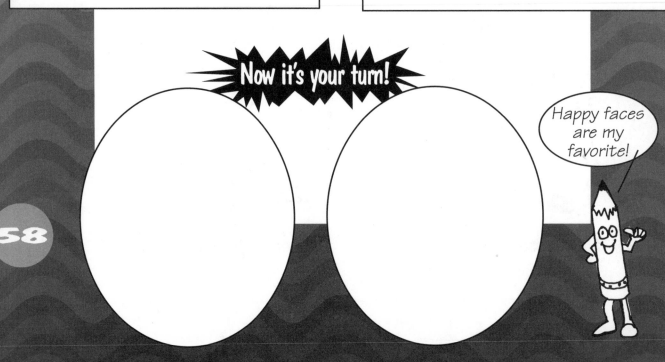

Happy faces are my favorite!

58

From Classroom Cartooning for the Artistically Challenged, published by Good Year Books. Copyright © 1997 Mike Artell.

Here are some facial features. Draw them on the oval and make a funny face.

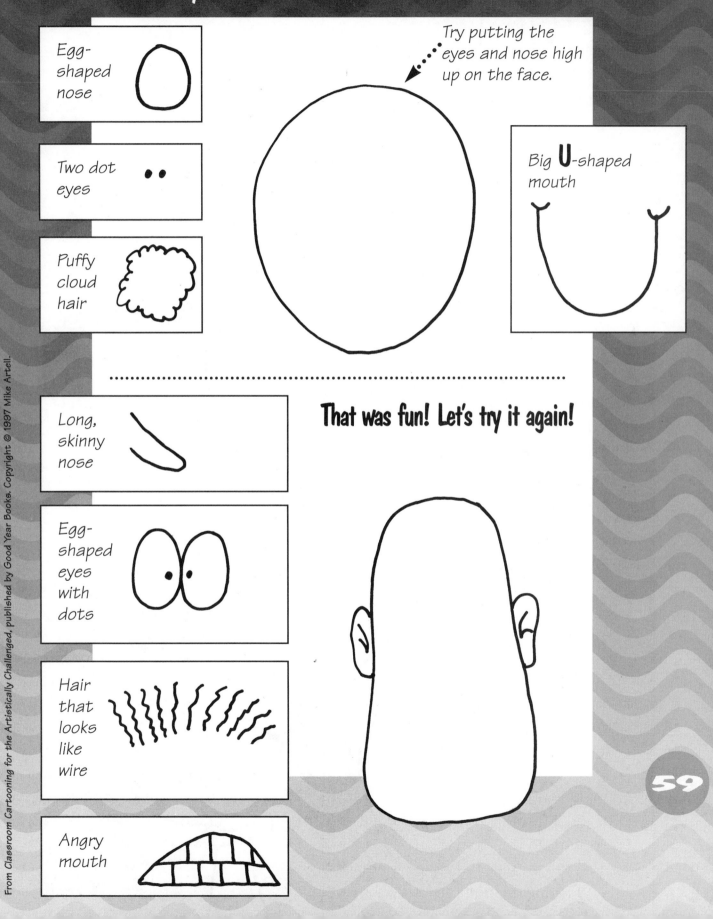

Egg-shaped nose

Two dot eyes

Puffy cloud hair

Try putting the eyes and nose high up on the face.

Big **U**-shaped mouth

That was fun! Let's try it again!

Long, skinny nose

Egg-shaped eyes with dots

Hair that looks like wire

Angry mouth

59

Faces

You know how to draw a happy face... just make a U shape, like an upside-down rainbow, like this:

If you want to "open" the mouth to show somebody talking or laughing, just put another upside-down rainbow under the first one. Like this:

Lets try it on some faces

Draw a happy face on this girl.

Now, "open" the mouth on this boy by using two upside-down rainbows.

Draw happy-face mouths on these faces.

Try drawing them either very low on the face or very close to the nose. Try making them very big or very small. After you draw them, erase the mouths and draw different ones.

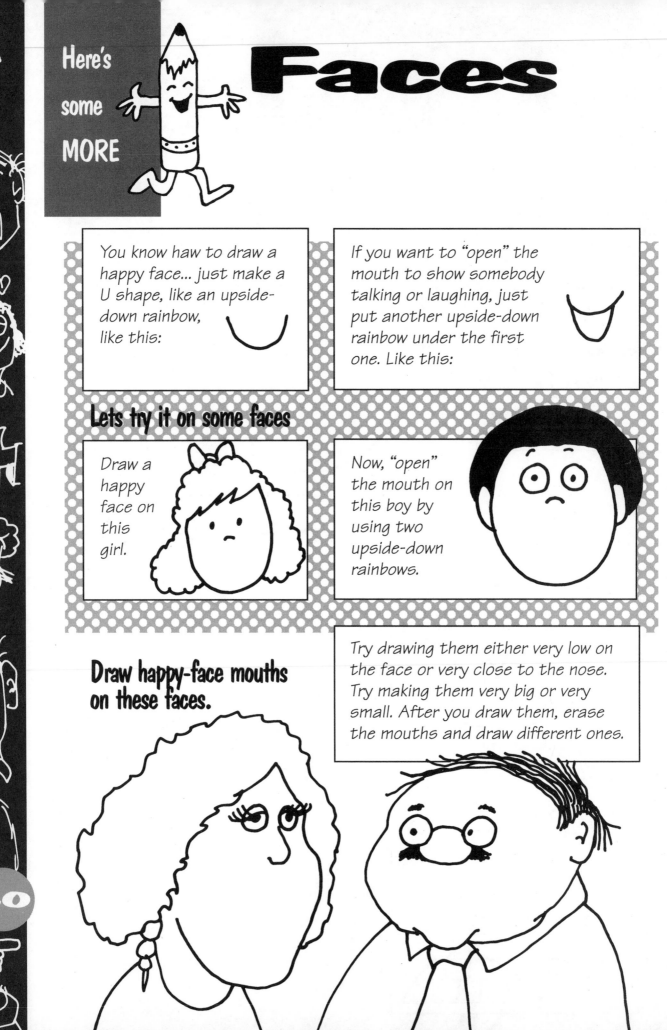

Let's draw some different

Facial Expressions:
Happiness

1.

Just for fun, draw a long, skinny head on a piece of paper. Add a nose that looks like a horseshoe.

2.

Now add two dot eyes and push them close together. Draw a smiley face right under the nose. Add some little curvy eyebrows.

3.

Open the mouth by drawing a big U under the smiley-face mouth. Erase the eyebrows you just drew and redraw them way up at the top of the page.

4.

Here's a super-smiley face. This is the kind of face you see when someone gets tickled. Notice that the eyes have turned into little rainbows and the eyebrows have popped OFF THE HEAD! Also, there are little "tears" squirting from the character's eyes. Sometimes that happens when you laugh very hard.

Let's make your character REALLY happy!

Facial Expressions:
Anger

When you are angry, something else happens to your face. Here's how to draw an angry face:

1. Draw an oval-shaped head and a rounded triangle nose. You can use other shapes if you're feeling creative, but you might try these shapes for starters.

2. Add some egg-shaped eyes and put the dots close to the nose. When you draw angry faces, draw heavy, dark eyebrows pointing down.

Notice that the eyebrows go down and in, like this.

3. Make the mouth turn down. You can make this mouth large or small.

4. If your character is REALLY angry, you might be able to see his clenched teeth and there may be "heat" lines coming from his head. There may even be smoke coming from his ears.

WOW! He REALLY looks mad!

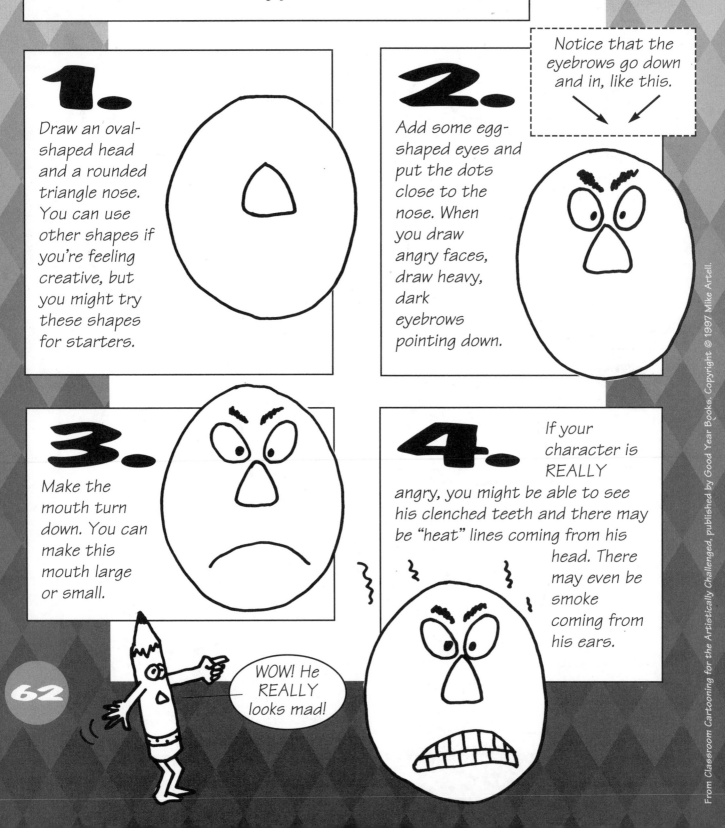

Facial Expressions: Fear

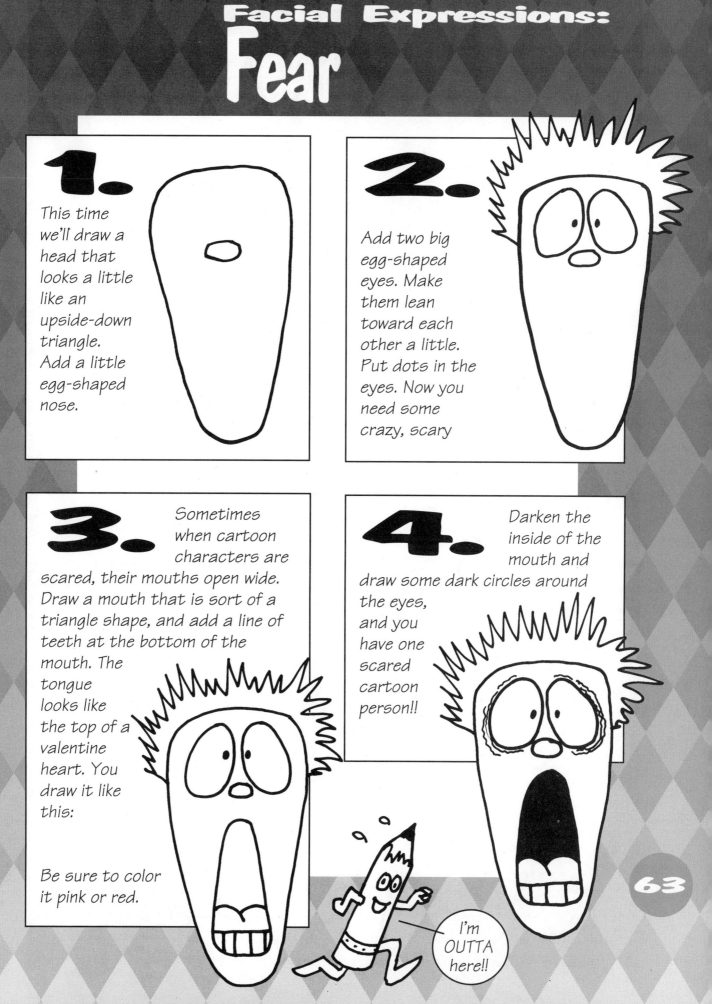

1. This time we'll draw a head that looks a little like an upside-down triangle. Add a little egg-shaped nose.

2. Add two big egg-shaped eyes. Make them lean toward each other a little. Put dots in the eyes. Now you need some crazy, scary

3. Sometimes when cartoon characters are scared, their mouths open wide. Draw a mouth that is sort of a triangle shape, and add a line of teeth at the bottom of the mouth. The tongue looks like the top of a valentine heart. You draw it like this:

Be sure to color it pink or red.

4. Darken the inside of the mouth and draw some dark circles around the eyes, and you have one scared cartoon person!!

I'm OUTTA here!!

Facial Expressions: Goofy Faces

I n order to draw goofy faces, it's important to draw things in unusual ways. For example, mouths may have to be drawn with a zigzag line instead of a smooth line, or the pupils of the eyes may have to be drawn in two different places. Here's an example of a goofy face and how to draw it:

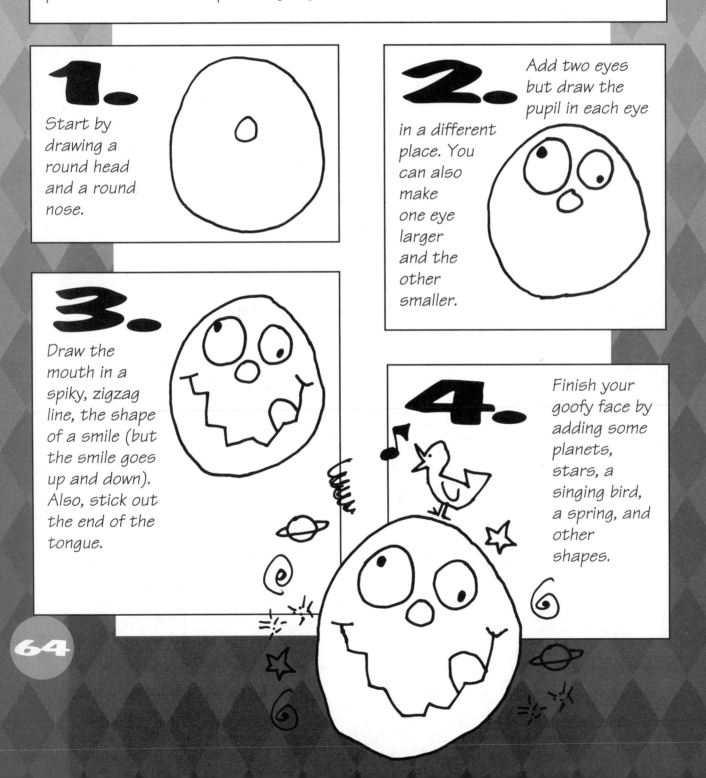

1. Start by drawing a round head and a round nose.

2. Add two eyes but draw the pupil in each eye in a different place. You can also make one eye larger and the other smaller.

3. Draw the mouth in a spiky, zigzag line, the shape of a smile (but the smile goes up and down). Also, stick out the end of the tongue.

4. Finish your goofy face by adding some planets, stars, a singing bird, a spring, and other shapes.

From Classroom Cartooning for the Artistically Challenged, published by Good Year Books. Copyright © 1997 Mike Artell.

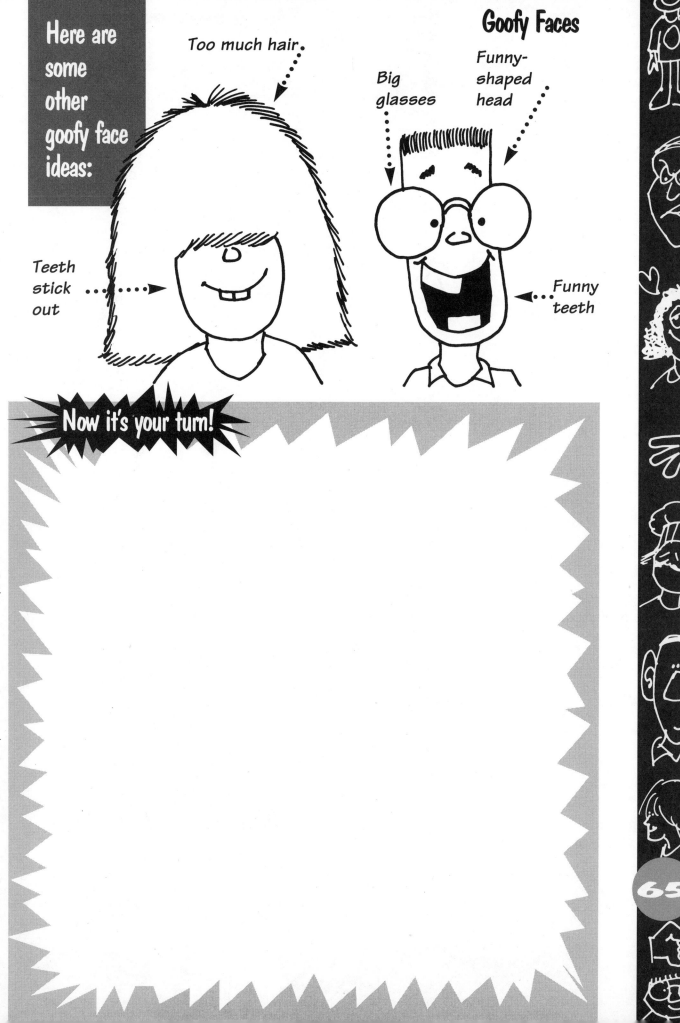

Here are some other goofy face ideas:

Too much hair.

Goofy Faces

Big glasses

Funny-shaped head

Teeth stick out

Funny teeth

Now it's your turn!

65

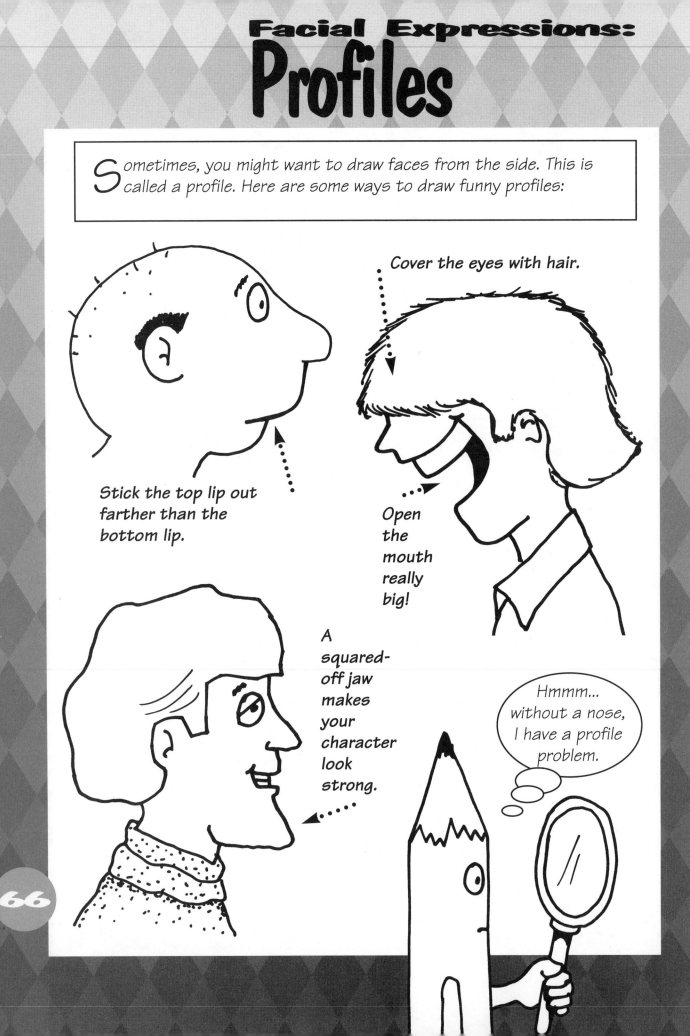

More Ideas for Faces

A suspicious face is simple to draw. Just make a line with a dot for each eye and a small mouth.

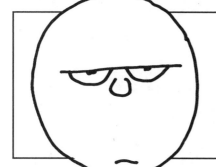

Someone who is losing his or her patience has different eyes, but they are easy to draw. Just make a long, horizontal line. Then draw two U shapes underneath it. Add pupils just under the long line.

A person who is thinking has round eyes with the pupils looking up. It also helps to draw a finger touching the mouth.

Now it's your turn!

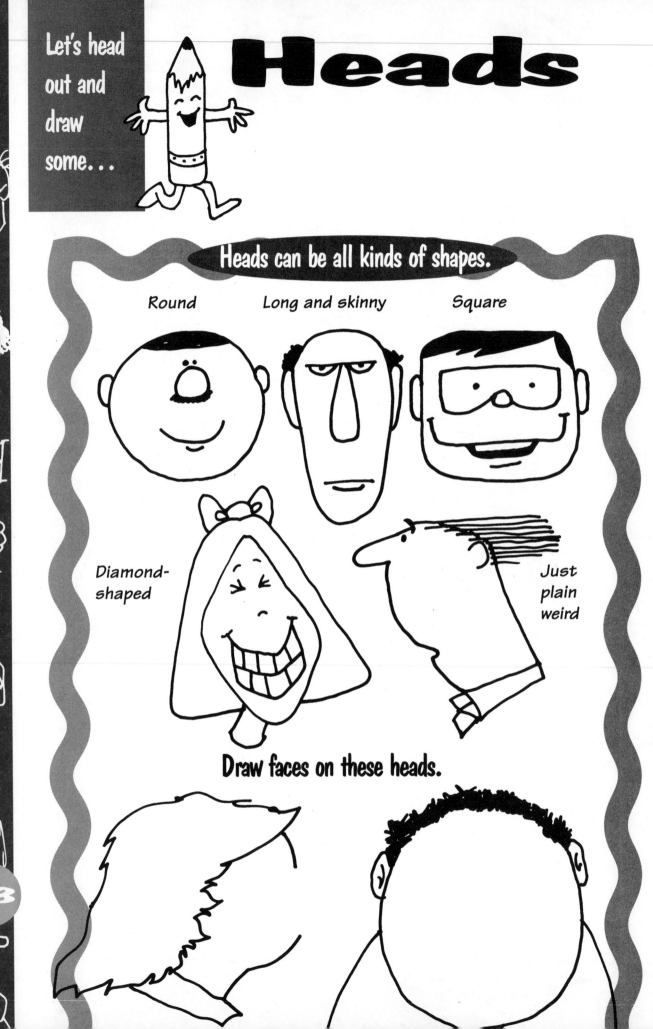

Let's head out and draw some...

Heads

Heads can be all kinds of shapes.

Round Long and skinny Square

Diamond-shaped

Just plain weird

Draw faces on these heads.

Think Funny!

Draw some heads around these faces. Remember to THINK FUNNY!

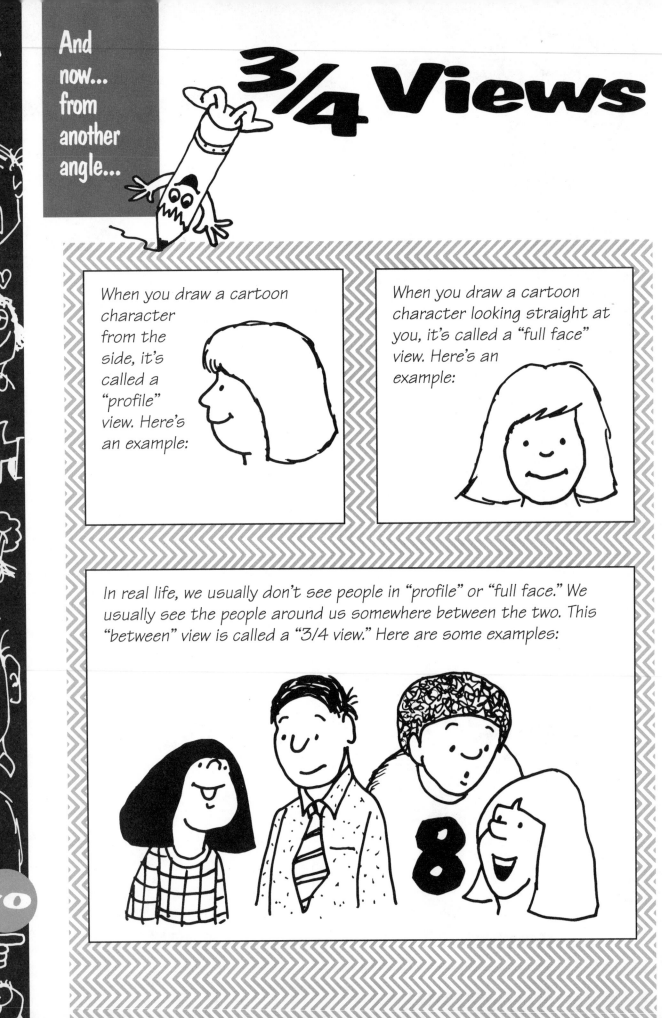

3/4 Views

When you draw a cartoon character from the side, it's called a "profile" view. Here's an example:

When you draw a cartoon character looking straight at you, it's called a "full face" view. Here's an example:

In real life, we usually don't see people in "profile" or "full face." We usually see the people around us somewhere between the two. This "between" view is called a "3/4 view." Here are some examples:

70

From *Classroom Cartooning for the Artistically Challenged*, published by Good Year Books. Copyright © 1997 Mike Artell.

1.

Draw a head. Any shape will do.

2. Imagine the head is a globe, like the earth. On the globe, draw a curved line between the north and south poles. Next, draw an equator line that is slightly curved.

Top to

Bottom

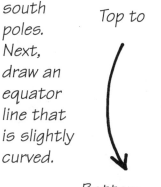

Side to side

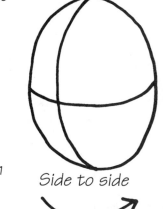

3.

The spot at which the two lines cross is where you want to draw the nose. Draw the nose so that it points in the same direction as the north pole/south pole line curves. In other words, if the polar line curves to the left, draw the nose pointing to the left.

4.

Erase the guidelines and add some facial features and hair, and you have drawn a 3/4 view that looks terrific!

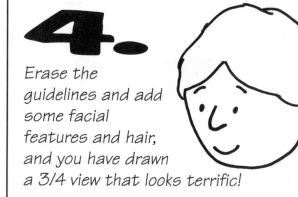

Remember...

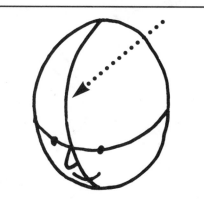

The more you curve the polar line, the more the head will turn left or right.

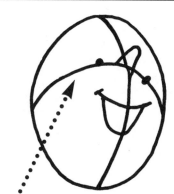

The more you curve the equator line, the more the head will move up or down.

71

3/4 Views

Now... let's have some fun with

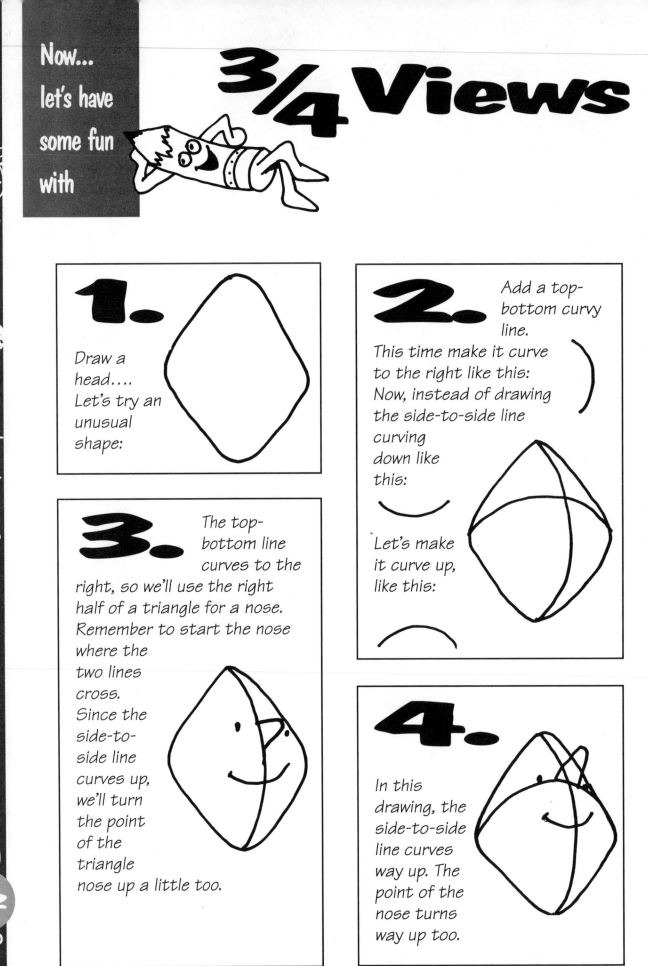

1.

Draw a head.... Let's try an unusual shape:

2. Add a top-bottom curvy line.

This time make it curve to the right like this:
Now, instead of drawing the side-to-side line curving down like this:

Let's make it curve up, like this:

3. The top-bottom line curves to the right, so we'll use the right half of a triangle for a nose. Remember to start the nose where the two lines cross. Since the side-to-side line curves up, we'll turn the point of the triangle nose up a little too.

4.

In this drawing, the side-to-side line curves way up. The point of the nose turns way up too.

It's easy to draw 3/4 views when you know how to curve the lines!

Here are some heads with top-bottom and side-to-side curvy lines.

Add eyes, mouths, and noses.

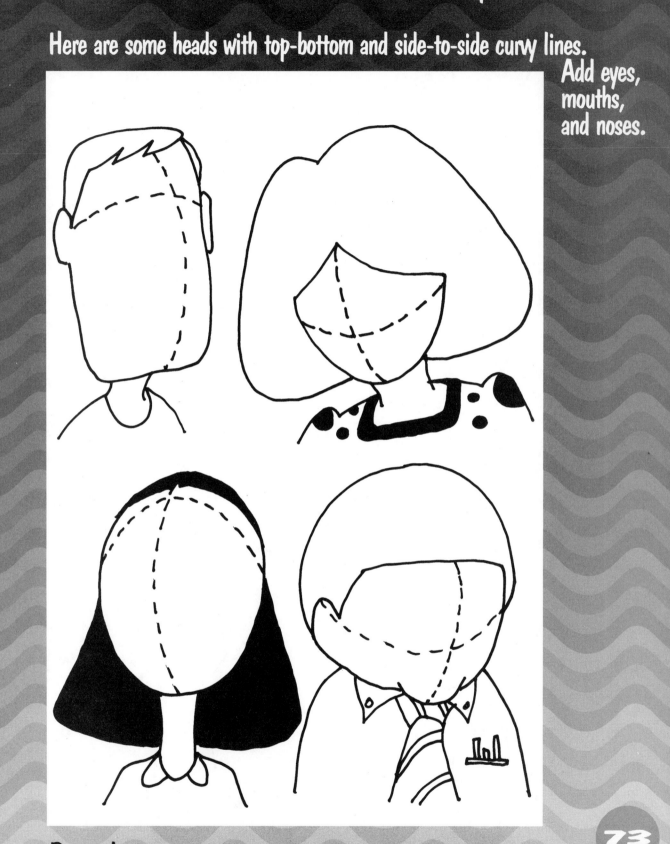

73

Remember... If the side-to-side curvy line curves up, then the tip of the nose turns up. If it curves down, point the nose down...but always start the nose where the lines cross.

Bodies

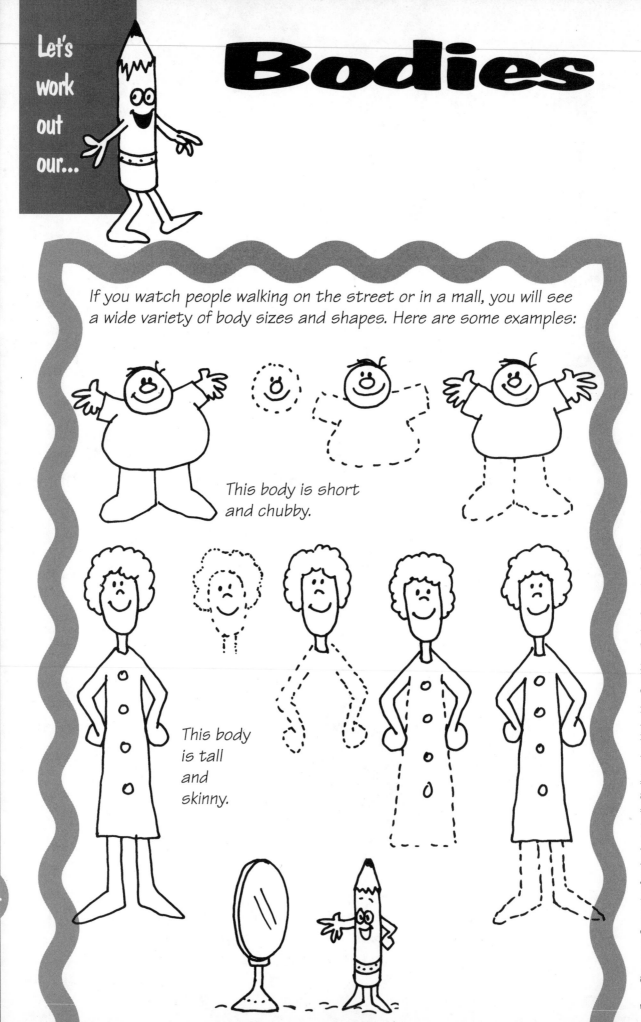

If you watch people walking on the street or in a mall, you will see a wide variety of body sizes and shapes. Here are some examples:

This body is short and chubby.

This body
is tall
and
skinny.

From *Classroom Cartooning for the Artistically Challenged*, published by Good Year Books. Copyright © 1997 Mike Artell.

Here are some tips for drawing bodies:

Angry bodies and sad bodies have no necks. Draw the shoulders up near the ears for these bodies.

Look! No neck!

People who are happy or excited usually have necks you can see.

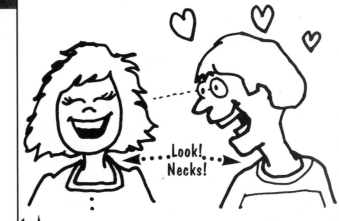

Look! Necks!

Now it's your turn!

Draw a short, chubby body to go with this face.

Draw a long, skinny body to go with this face.

Finish drawing the bodies on these characters

From Classroom Cartooning for the Artistically Challenged, published by Good Year Books. Copyright © 1997 Mike Artell.

Think Funny!

Sometimes it's really funny to put a very large head on a little tiny body. People who draw caricatures do this all the time. In the space below, try drawing some large heads on tiny bodies. Use different body styles (e.g. short/fat, tall/skinny, etc.).

Try drawing your big head/tiny body people in motion. Make them run or jump, or put them bouncing up and down on a trampoline. Try different occupations too...draw a football player with a huge head and a little bitty body running for a touchdown. Or make a big head/tiny body rock star singing with a microphone.

Hands

There are lots of ways to draw hands. Some hands are long and skinny.

Some hands are short and chubby.

Like mine!

1. First, for practice, draw a simple flower that looks something like this:

Draw a flower here.

2. When you drew the petals, you probably made big loops. If you can draw big loops, you can draw hands. Lets draw some loops together.

Trace these loops and practice drawing some more loops.

Now it's your turn!

From Classroom Cartooning for the Artistically Challenged, published by Good Year Books. Copyright © 1997 Mike Artell.

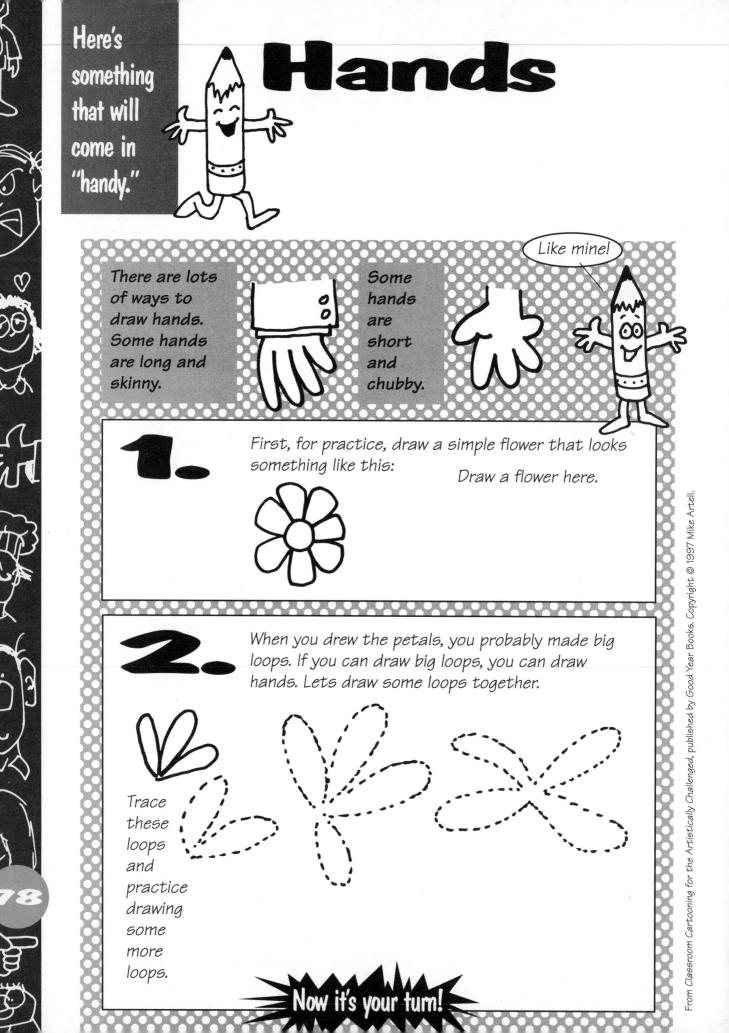

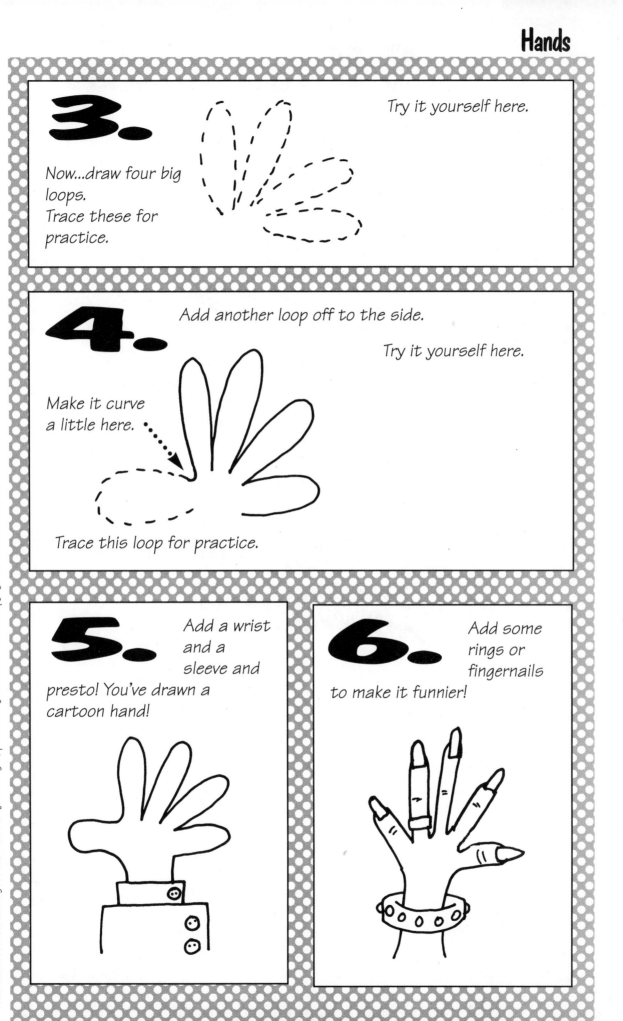

3.

Now...draw four big loops.
Trace these for practice.

Try it yourself here.

4.

Add another loop off to the side.

Try it yourself here.

Make it curve a little here.

Trace this loop for practice.

5.

Add a wrist and a sleeve and presto! You've drawn a cartoon hand!

6.

Add some rings or fingernails to make it funnier!

Hands

1.
If you want to show the hand pointing, just draw a loop, a thumb, and three small bumps, like this:

loop •••
thumb •••
•••• bumps

2.
Then turn it sideways

They went that-a-way...

Now it's your turn!

From Classroom Cartooning for the Artistically Challenged, published by Good Year Books. Copyright © 1997 Mike Artell.

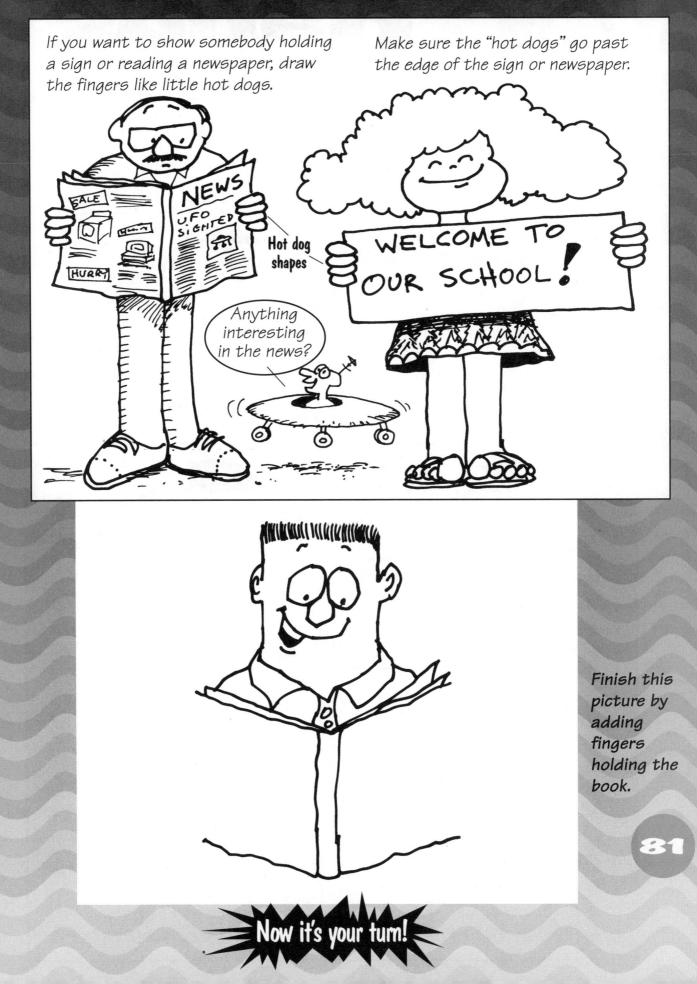

81

Now it's your turn!

Hands

1. To draw an "inside view" of a hand pointing, start by drawing a little rounded hill.

2. Now, make two smiley-face shapes, one large, the other small.

Big smile shape Little smile shape

3. Next, we need a long "hot dog"-shaped finger.

4. Add some smaller "hot dogs," and a rounded shape at the bottom.

5. Add a wrist, and a sleeve, and you've done it again! You've drawn a hand!

OOPS...

Hint:
If your hand looks a little weird, you may have made the fingers too thick. Remember to keep the "hot dog" fingers skinny.

82

From Classroom Cartooning for the Artistically Challenged, published by Good Year Books. Copyright © 1997 Mike Artell.

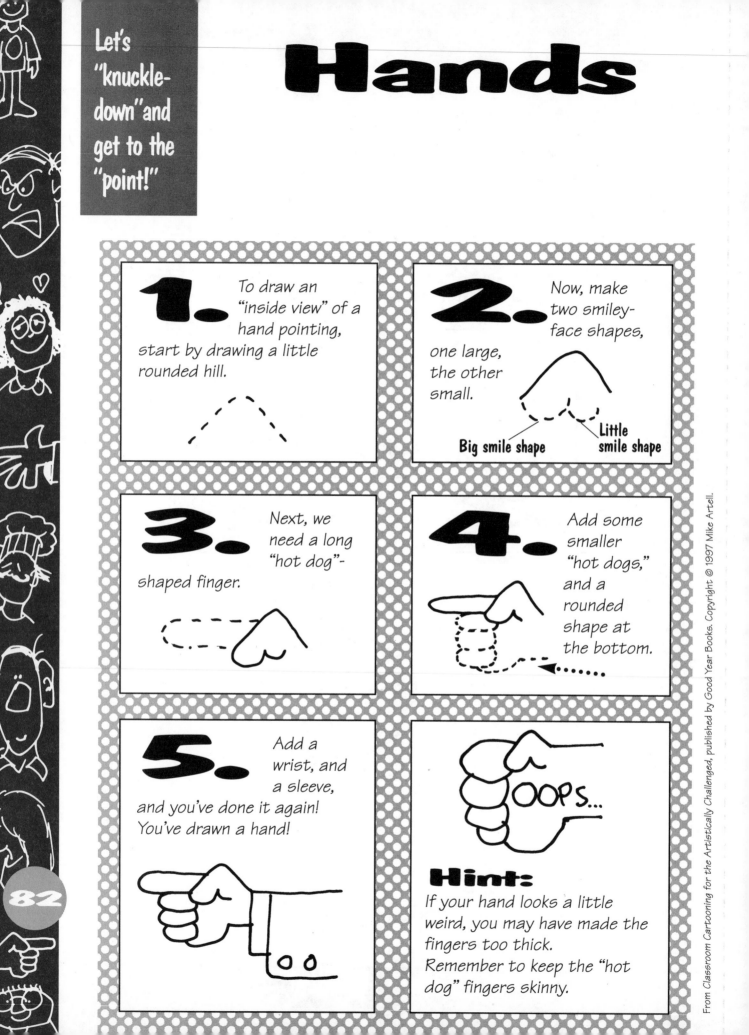

Think Funny!

Think of some funny ways to use hands. People say that a clock has "hands." Draw a clock with hands instead of arrows pointing to the time. Animals usually have paws, but they sometimes look funnier if you draw them with human hands instead of paws.

Draw an animal with human hands instead of paws.

Sometimes people use expressions like "Hand-to-Hand Combat." A funny drawing of that would be two hands fighting. Try drawing these "hand" expressions:

handspring
Hands up!
hand tool
handshake

Feet

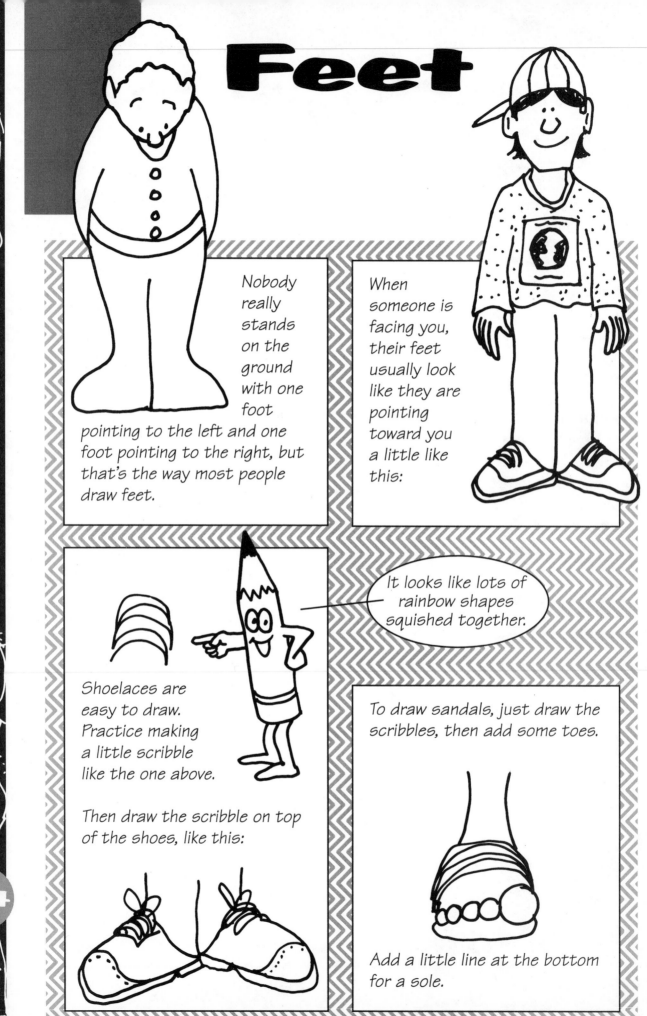

Nobody really stands on the ground with one foot pointing to the left and one foot pointing to the right, but that's the way most people draw feet.

When someone is facing you, their feet usually look like they are pointing toward you a little like this:

It looks like lots of rainbow shapes squished together.

Shoelaces are easy to draw. Practice making a little scribble like the one above.

Then draw the scribble on top of the shoes, like this:

To draw sandals, just draw the scribbles, then add some toes.

Add a little line at the bottom for a sole.

From Classroom Cartooning for the Artistically Challenged, published by Good Year Books. Copyright © 1997 Mike Artell.

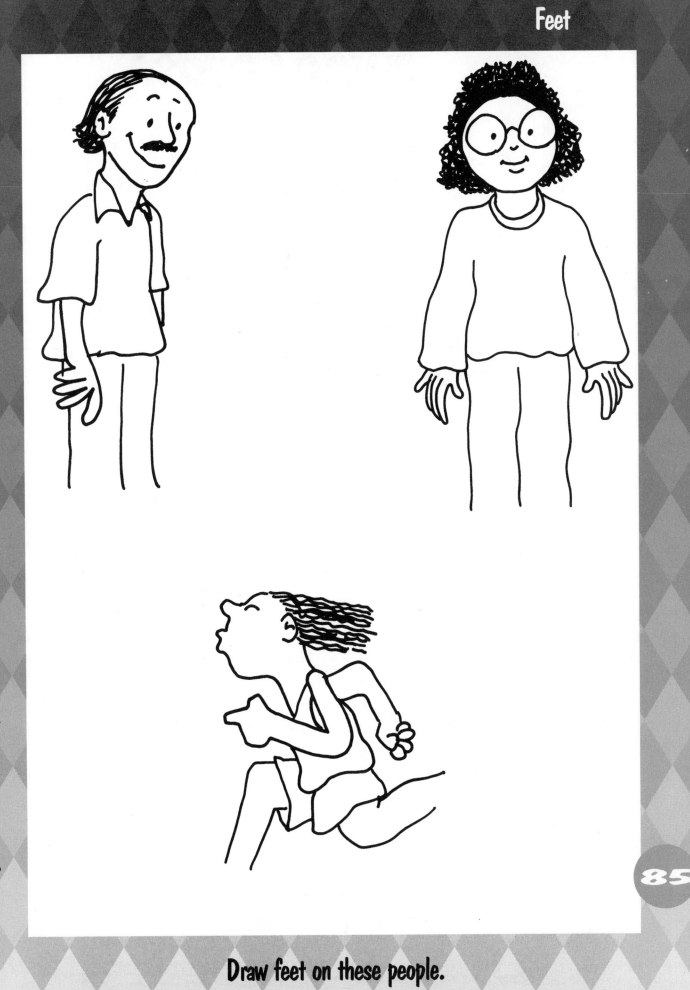

Draw feet on these people.

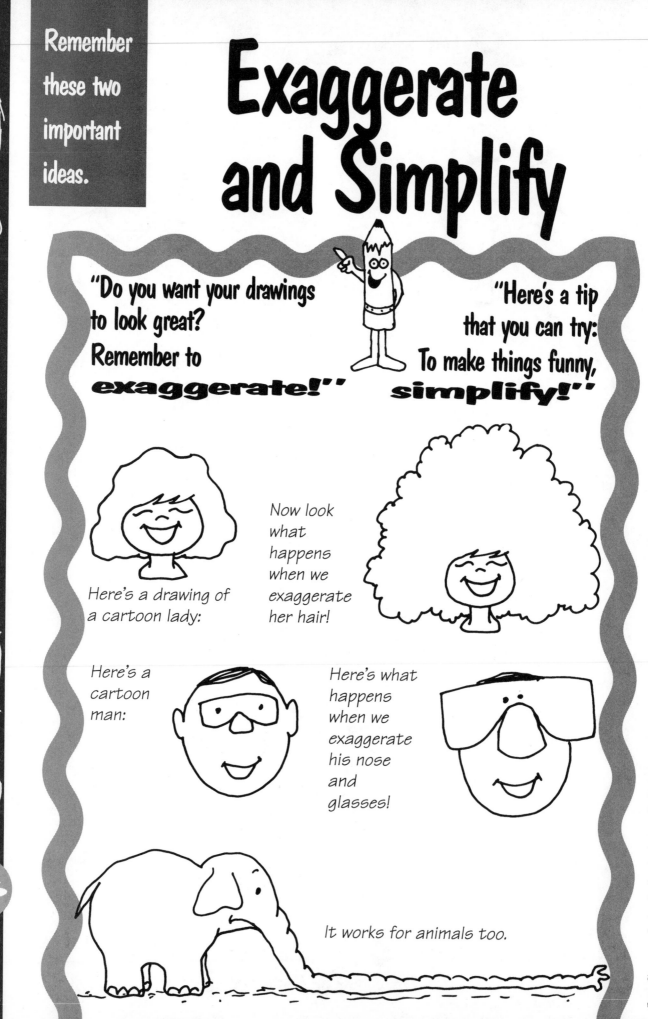

Exaggerate and Simplify

"Do you want your drawings to look great? Remember to **exaggerate!"**

"Here's a tip that you can try: To make things funny, **simplify!"**

Here's a drawing of a cartoon lady:

Now look what happens when we exaggerate her hair!

Here's a cartoon man:

Here's what happens when we exaggerate his nose and glasses!

It works for animals too.

From Classroom Cartooning for the Artistically Challenged, published by Good Year Books. Copyright © 1997 Mike Artell.

Here's a
normal-
looking
cartoon
character.
What
could you
exaggerate
to make
him look
funnier?

Try
exaggerating
some or all
of the
character's
facial
features.

This
character is
running.

What
could you
exaggerate
to make him
even funnier?
Sometimes
long legs are
funny.
Sometimes
people lean
way over
when they
run fast.

87

Here's a profile view of a girl talking. In
the space above, draw this girl with
something exaggerated.

Think Funny!

Do you like jokes and riddles? They're fun to say and they're a great way to practice cartooning. All you have to do is create characters and put the words of the joke or riddle in the characters' caption balloons.

Now...here are some riddles for you to try. Create some characters. They can be humans, animals, space creatures, or things (like cars or televisions). Put the words of the riddle in the caption balloons and create your own mini-comic strip!

Here's a joke:

Person 1: Where do sheep get their hair cut?

Person 2: Hmmm . . . at the beauty parlor?

Person 1: Nope . . . at the BAA BAA shop!

From Classroom Cartooning for the Artistically Challenged, published by Good Year Books. Copyright © 1997 Mike Artell.

Think Funny!

Now try illustrating this joke:

Person 1: Why did the chicken cross the playground?

Person 2: To get to the other side?

Person 1: Nope ...to get to the other SLIDE!

Movement

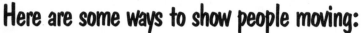

Here are some ways to show people moving:

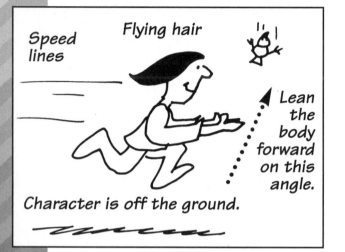

Speed lines

Flying hair

Lean the body forward on this angle.

Character is off the ground.

Try it!

When you are drawing characters throwing a ball, draw them at the "end" of the motion.

This pitcher has just thrown the ball. The curved lines show where the arm came from.

Two half circles show the path of the arm.

Little "hooked" lines show a bouncing-type motion.

Now it's your turn!

From Classroom Cartooning for the Artistically Challenged, published by Good Year Books. Copyright © 1997 Mike Artell.

Movement

Close up

Sometimes if you overlap a portion of a drawing on top of itself, you can make part of the drawing look like it's moving. Here's an example:

Now it's your turn!

Props, Uniforms, and Costumes

Sometimes what a cartoon character is wearing can tell you a lot about him or her. Here are some examples:

Doctors *don't wear these little mirrors on top of their heads anymore, but cartoonists sometimes still draw them.*

UH-OH!!!

Long white coats

Astronauts wear spacesuits.

Chefs wear tall hats.

Rock stars have guitars.

Let's do some drawing!

From *Classroom Cartooning for the Artistically Challenged*, published by Good Year Books. Copyright © 1997 Mike Artell.

Here's the face of a big, tough football player. Draw the rest of his helmet. Write the name of your favorite team on the front.

This lady just won a beauty contest. Draw a crown on her head. Draw a sash that says "Miss Cartoon."

This painter is painting a door. Draw a paintbrush in one hand and a bucket of paint in the other.

93

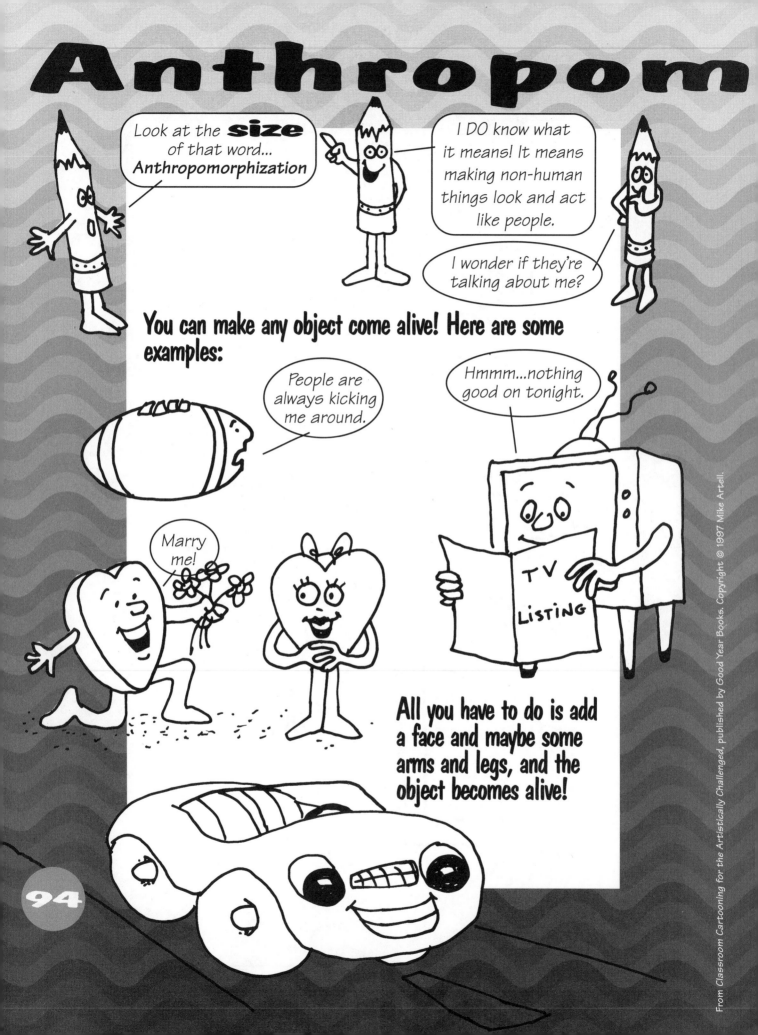

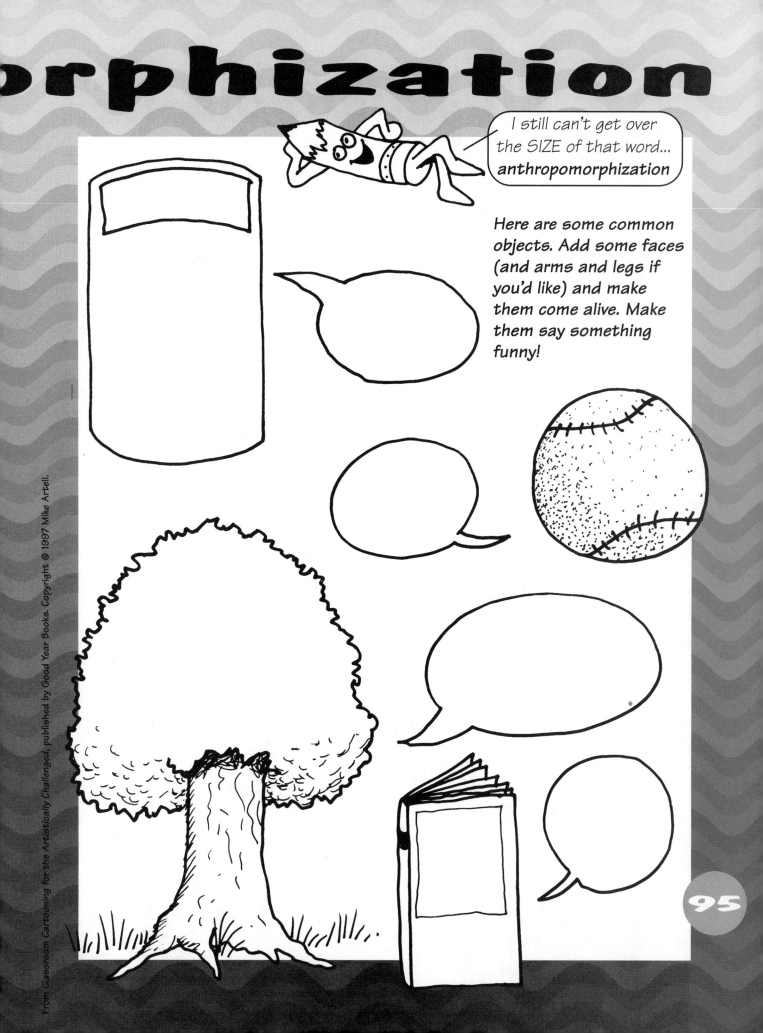

I still can't get over the SIZE of that word... **anthropomorphization**

Here are some common objects. Add some faces (and arms and legs if you'd like) and make them come alive. Make them say something funny!

Anthropomorphization

square circle rectangle triangle

If you can draw these four basic shapes, you can draw a robot!

All you have to do is "stack" the shapes, like this:

Try mixing up the shapes too. Here are some different kinds of heads.

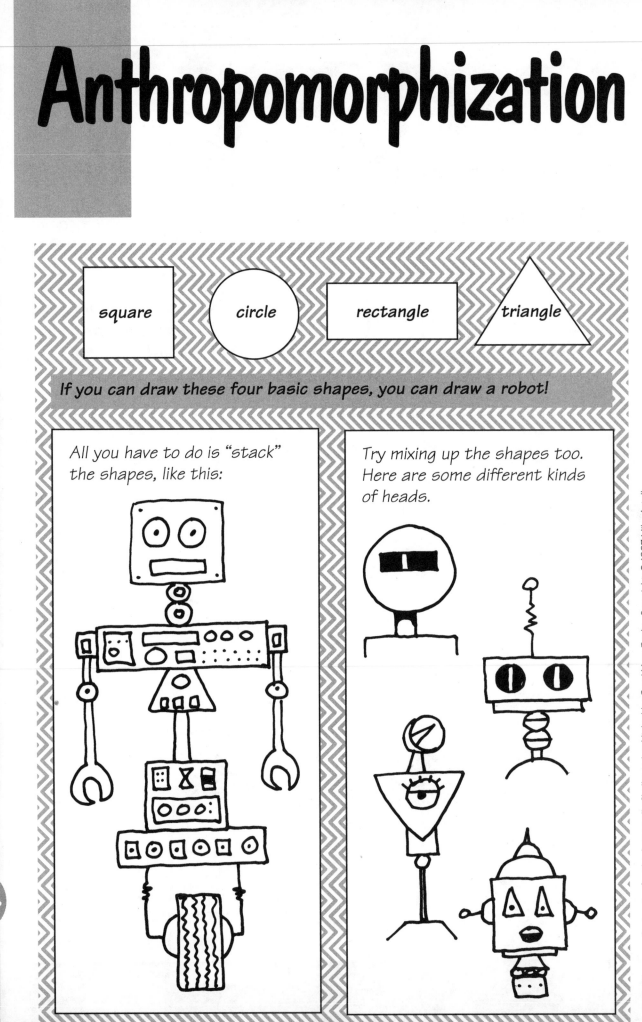

96

From Classroom Cartooning for the Artistically Challenged, published by Good Year Books. Copyright © 1997 Mike Artell.

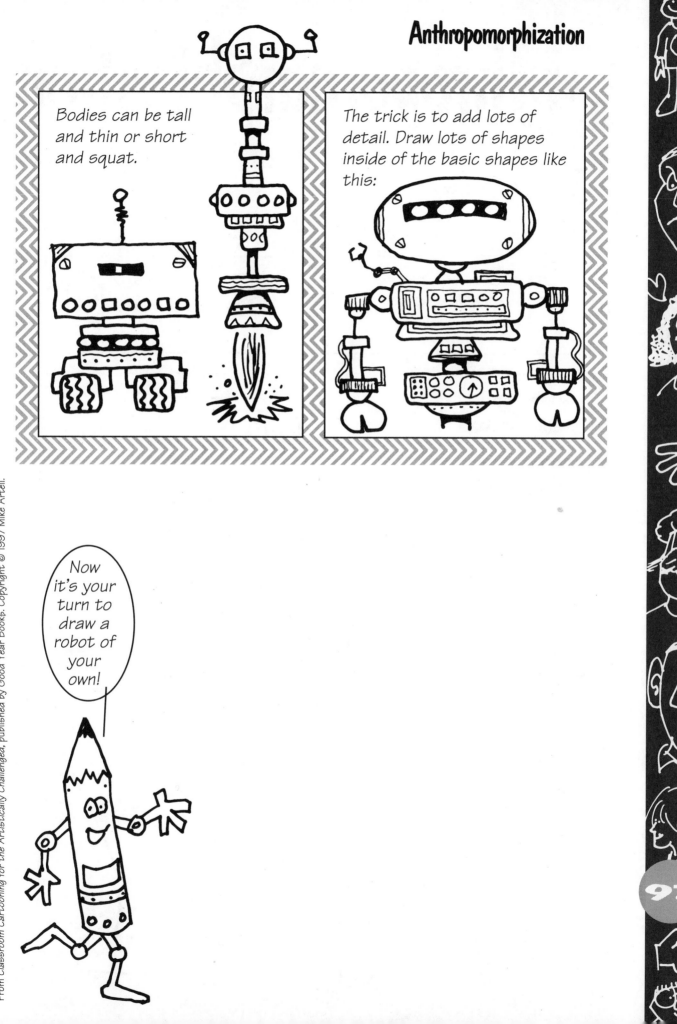

Bodies can be tall and thin or short and squat.

The trick is to add lots of detail. Draw lots of shapes inside of the basic shapes like this:

Now it's your turn to draw a robot of your own!

Anthropomorphization

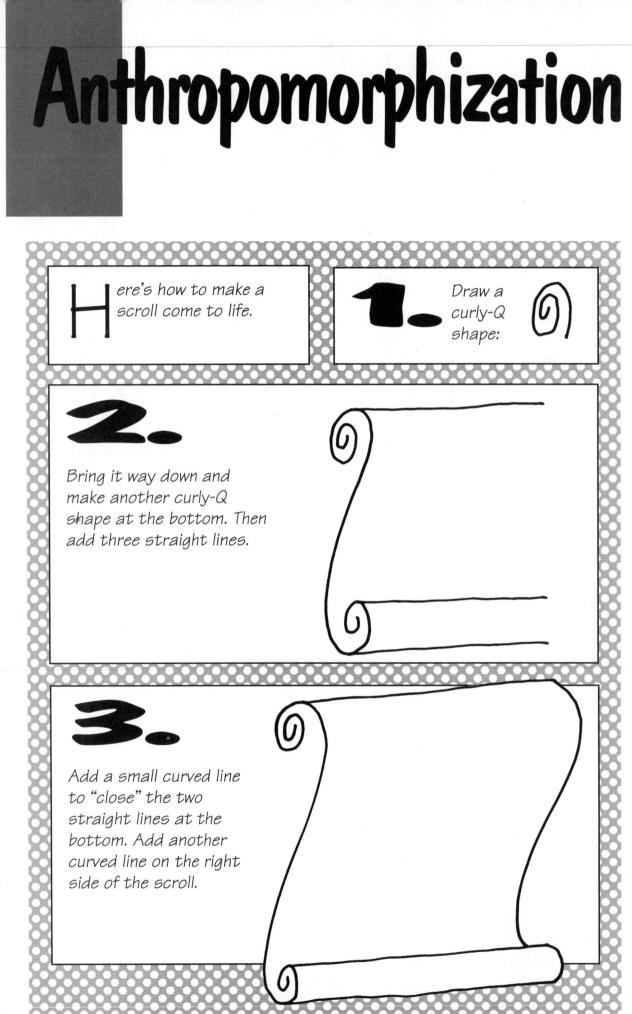

Here's how to make a scroll come to life.

1. Draw a curly-Q shape:

2. Bring it way down and make another curly-Q shape at the bottom. Then add three straight lines.

3. Add a small curved line to "close" the two straight lines at the bottom. Add another curved line on the right side of the scroll.

98

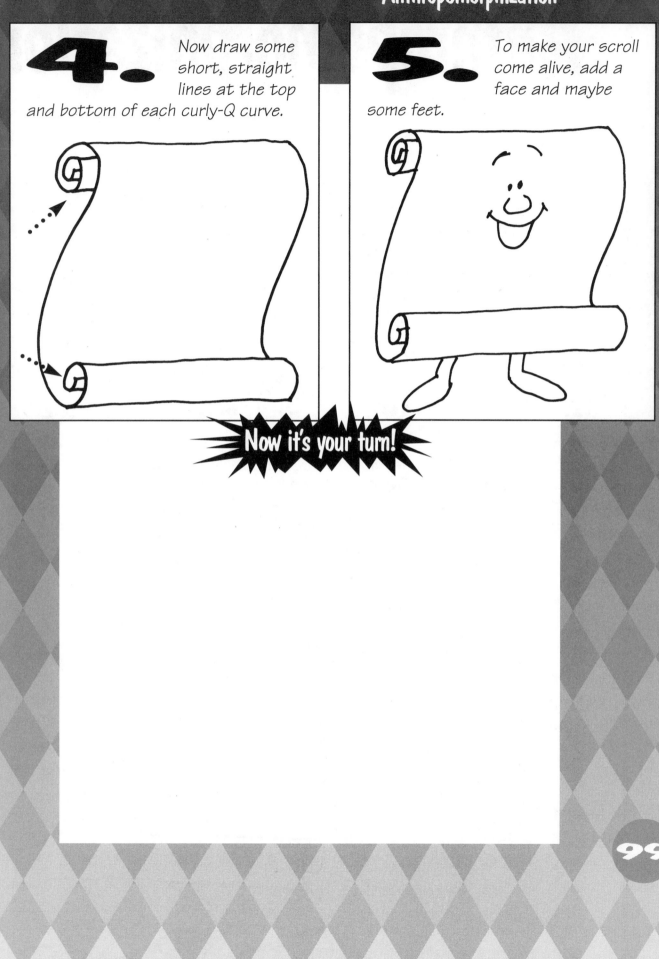

4. Now draw some short, straight lines at the top and bottom of each curly-Q curve.

5. To make your scroll come alive, add a face and maybe some feet.

Now it's your turn!

Anthropomorphization

Here's an idea...the next time you have to write a report about an old document like the Declaration of Independence or the Louisiana Purchase, draw a scroll. Then label the scroll with the document's name and have the document tell you about itself. It's a nice change from a report with words only. Look....

Old Way

New Way

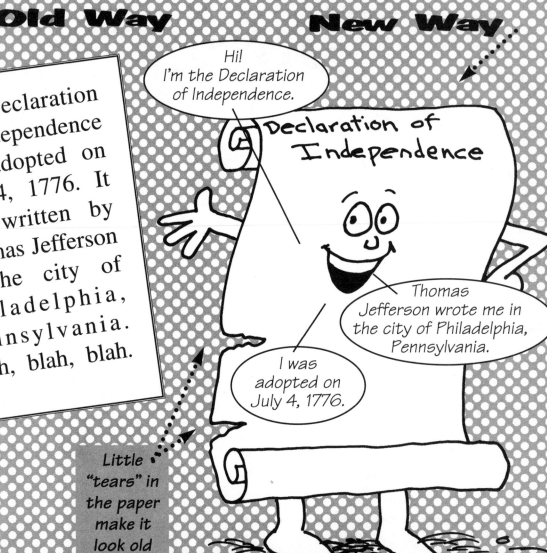

The Declaration of Independence was adopted on July 4, 1776. It was written by Thomas Jefferson in the city of Philadelphia, Pennsylvania. Blah, blah, blah.

Hi! I'm the Declaration of Independence.

Declaration of Independence

Thomas Jefferson wrote me in the city of Philadelphia, Pennsylvania.

I was adopted on July 4, 1776.

Little "tears" in the paper make it look old

100

If you draw a long, skinny scroll and turn it sideways, it makes a great banner. Turn this page sideways to see what I mean.

Can you write a big announcement on this banner?

From Classroom Cartooning for the Artistically Challenged, published by Good Year Books. Copyright © 1997 Mike Artell.

Backgrounds

Backgrounds can add a lot to your drawings and they're easy to draw! Watch...

Here's a drawing of a little girl.

Looks O.K., but it needs some background.

Here's the same little girl with a "picnic" background.

Add some grass.

Draw puffy-cloud trees and bushes.

Blanket

Food

Here's our little girl at the amusement park.

Draw a big circle for the Ferris wheel.

Balloon

Draw different-sized rectangles for buildings.

Add triangle-shaped seats.

Look who just caught a fish!

Fishing pole with fish

Sailboat and wiggly lines for water

Add trees and bushes.

WOW! It really makes a difference!

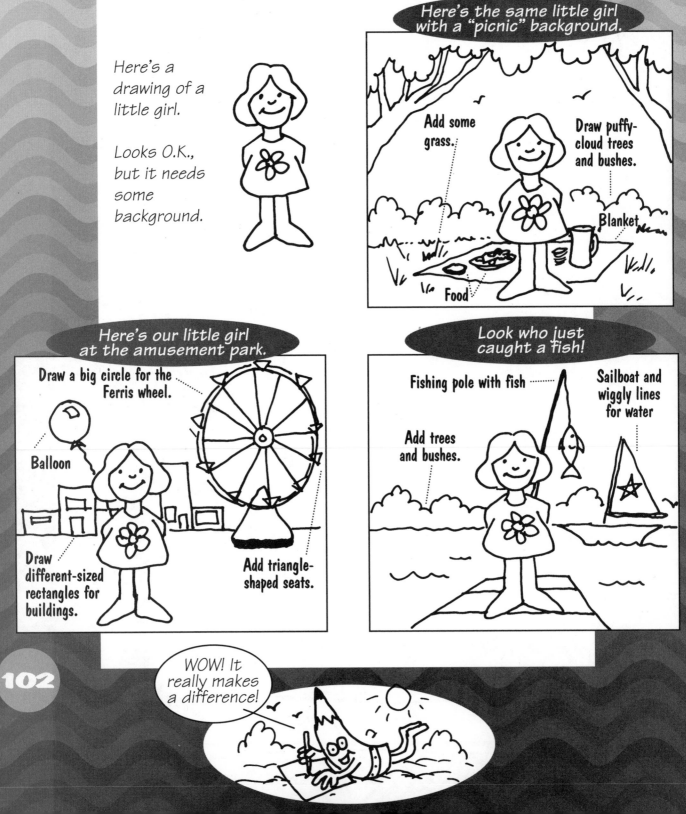

Draw some backgrounds behind these people.

103

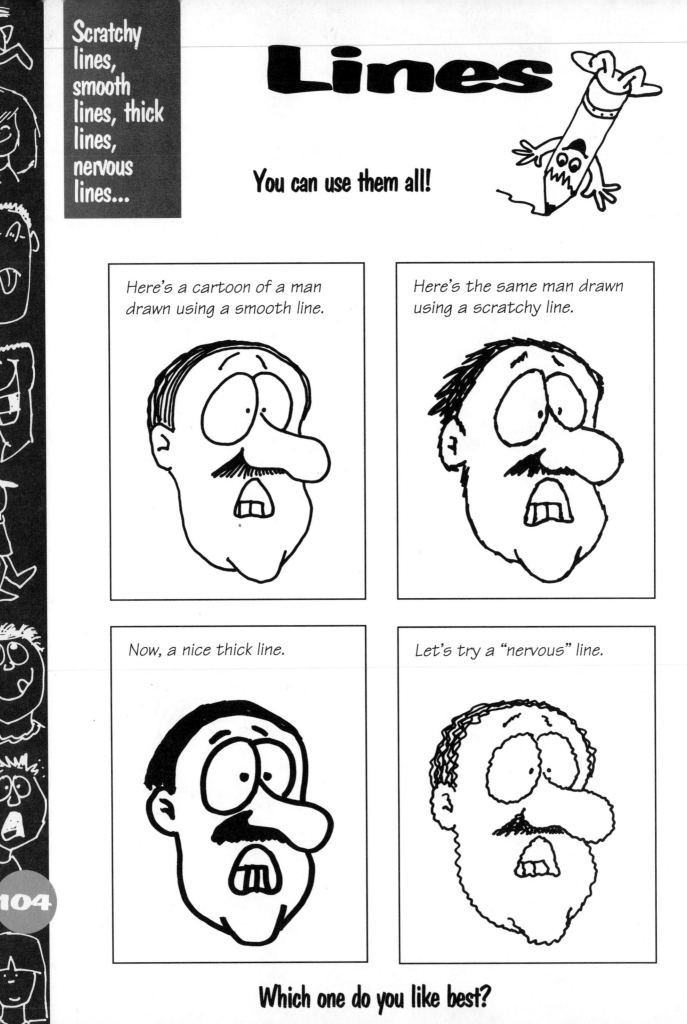

From Classroom Cartooning for the Artistically Challenged, published by Good Year Books. Copyright © 1997 Mike Artell.

Let's draw together. On the left, I'll draw a picture and on the right, you draw the same picture using a different kind of line. Here's an example:

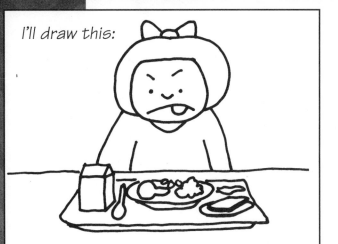

I'll draw this:

Little girl looking at yuccky school cafeteria food—smooth line.

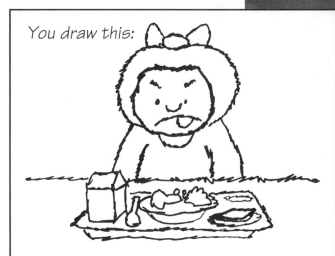

You draw this:

Little girl looking at yuccky school cafeteria food—scratchy line.

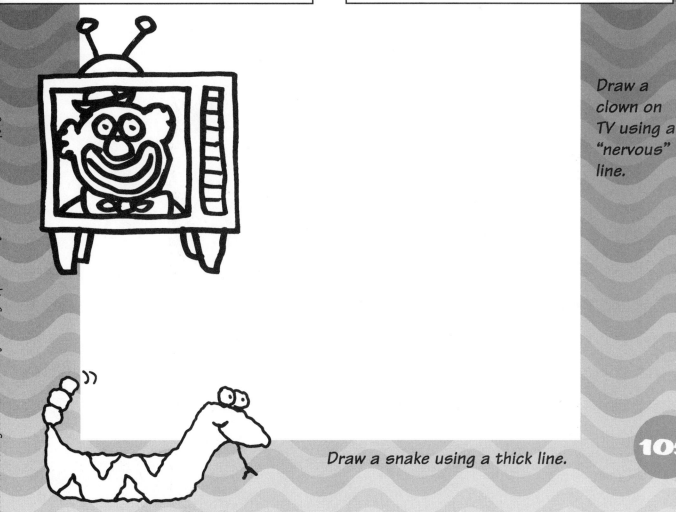

Draw a clown on TV using a "nervous" line.

Draw a snake using a thick line.

Think Funny!

Want to have some fun? Cut out the cartoons from old magazines and newspapers (Get permission first!) and cut off the captions. The captions are the words written below the cartoon or in the caption balloons. Captions are the words that the cartoon characters say.

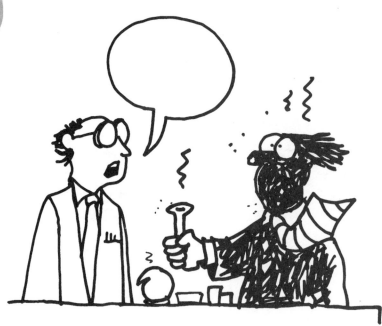

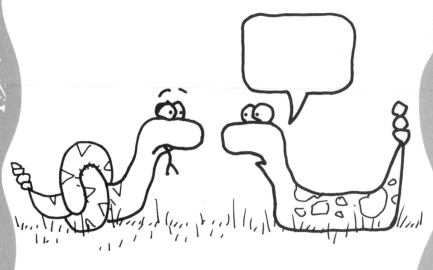

After you've cut off the captions, try writing your own funny captions. In fact, try writing two or three different funny captions for each of the cartoons. To give you some practice, try writing something funny for the characters to say in the cartoons here. Have fun and remember to THINK FUNNY!

Think Funny!

Now, let's try drawing some cartoons to go with these captions. You can draw people, animals, robots, etc. In fact, it might be funny to try some of each!

Whatever you do, don't sneeze!

EEEWWW... THAT'S DISGUSTING!

Maybe I should have read the directions.

Holiday Cartooning

In this section, you'll learn how to draw holiday cartoons. You'll learn how to draw. . .

Christmas cartoons

and Easter cartoons,

110

From *Classroom Cartooning for the Artistically Challenged*, published by Good Year Books. Copyright © 1997 Mike Artell.

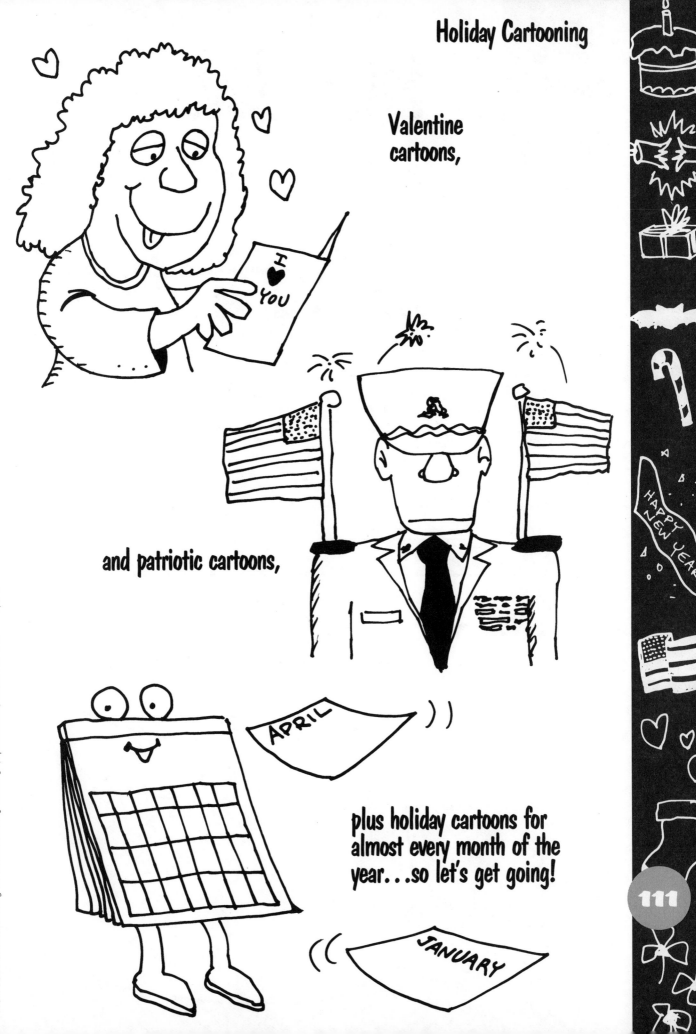

Valentine
cartoons,

and patriotic cartoons,

plus holiday cartoons for
almost every month of the
year...so let's get going!

I ♥ YOU

APRIL

JANUARY

Birthdays

Even though birthdays are not usually holidays, they are a time for fun and celebration. Here's a birthday cake you can draw.

1. Birthday cakes can be drawn in just a few steps. First draw a round top with drippy icing.

Make a little curvy line here.

2. Draw two straight lines for the sides and add a curvy line for the bottom.

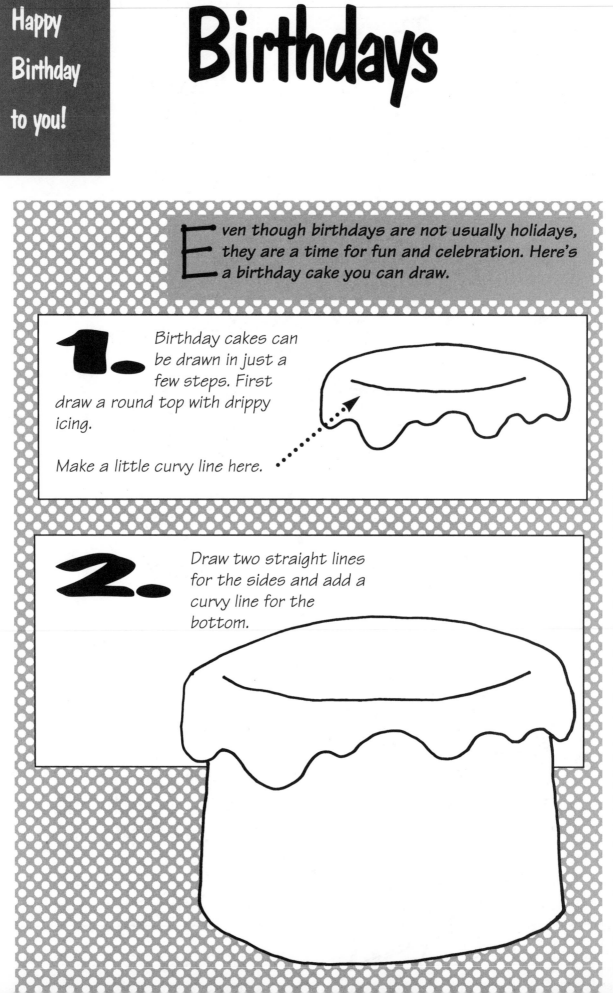

3.

Add icing decorations and a candle and you have a birthday cake!

Draw a big birthday cake for this girl to eat.

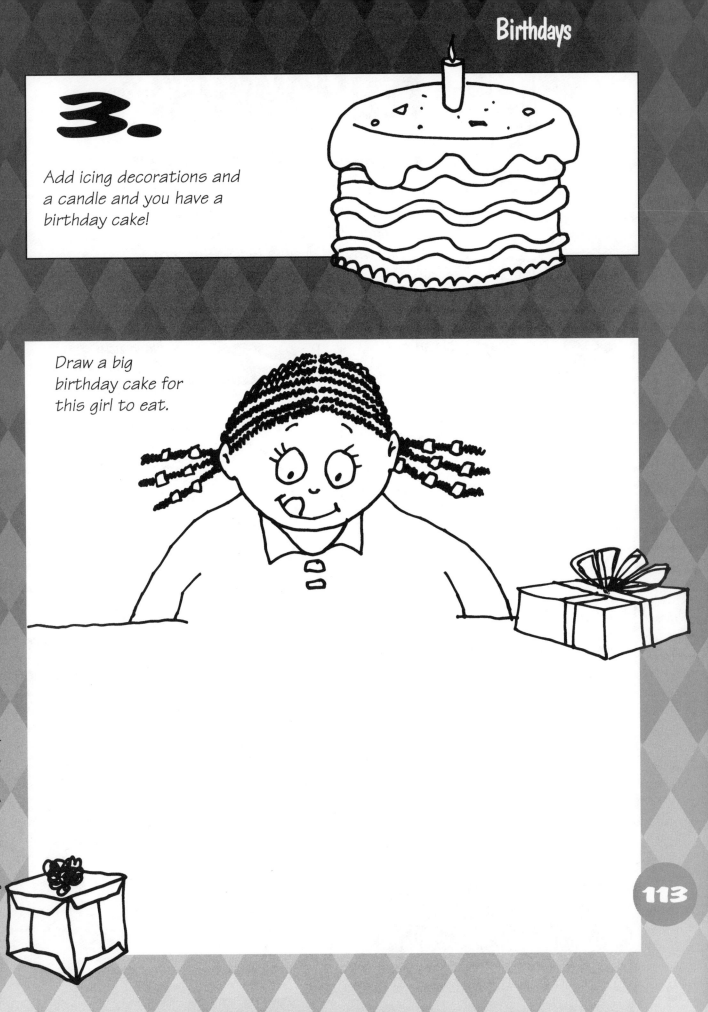

Halloween

Trick or Treat!

It's time for Halloween and that means it's time for jack-o'-lanterns and bats and other Halloween characters. Here's a quick way to draw a jack-o'-lantern.

1. Start with an oval shape that is bumpy on the top and bottom, like this:

2. Now, add another bumpy line at the top:

3. Next, add some curvy lines from each of the bumps to the bottom of the jack-o'-lantern.

Add a stem!

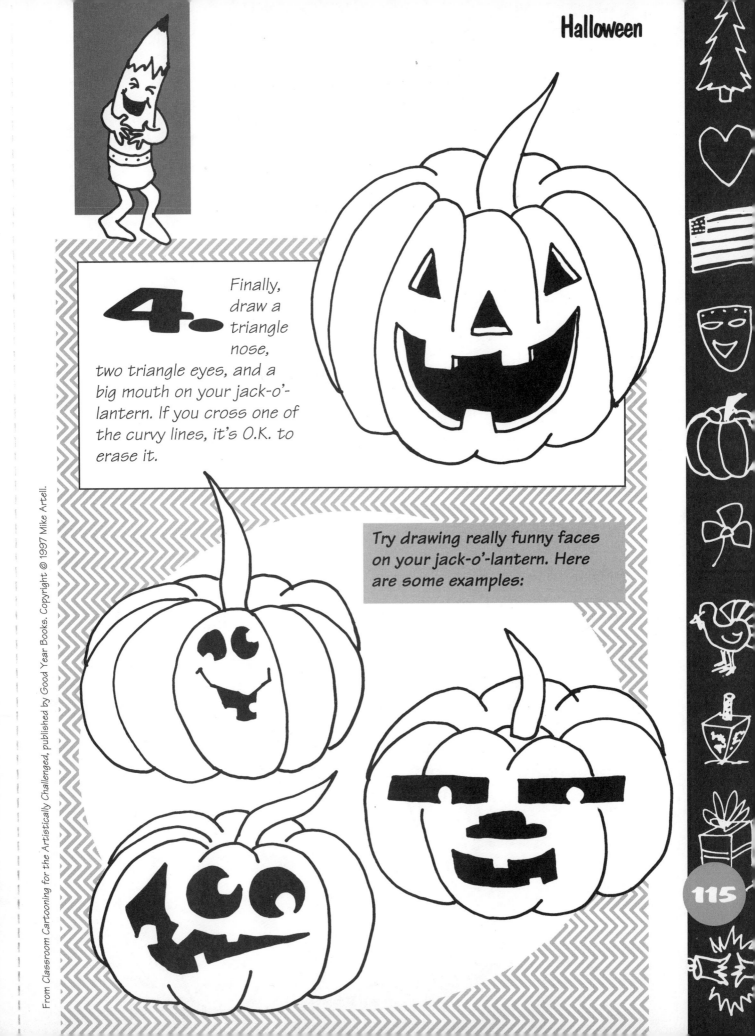

4. Finally, draw a triangle nose, two triangle eyes, and a big mouth on your jack-o'-lantern. If you cross one of the curvy lines, it's O.K. to erase it.

Try drawing really funny faces on your jack-o'-lantern. Here are some examples:

115

Pumpkins

Draw some faces on these jack-o'-lanterns:

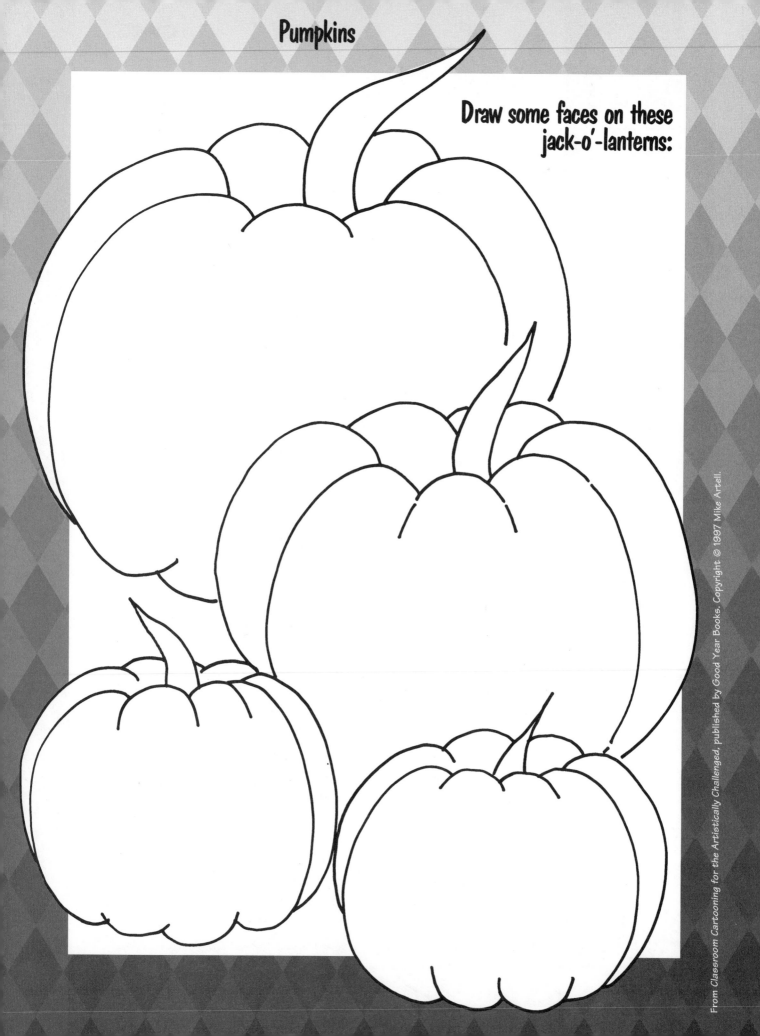

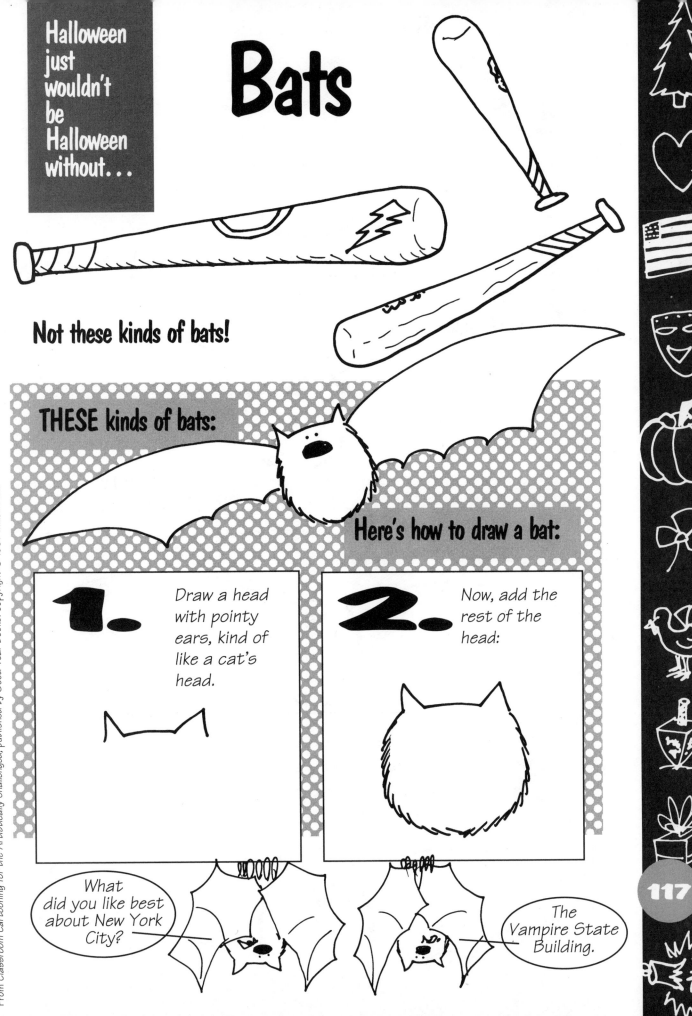

Bats

Halloween just wouldn't be Halloween without...

Not these kinds of bats!

THESE kinds of bats:

Here's how to draw a bat:

1. Draw a head with pointy ears, kind of like a cat's head.

2. Now, add the rest of the head:

What did you like best about New York City?

The Vampire State Building.

117

Bats

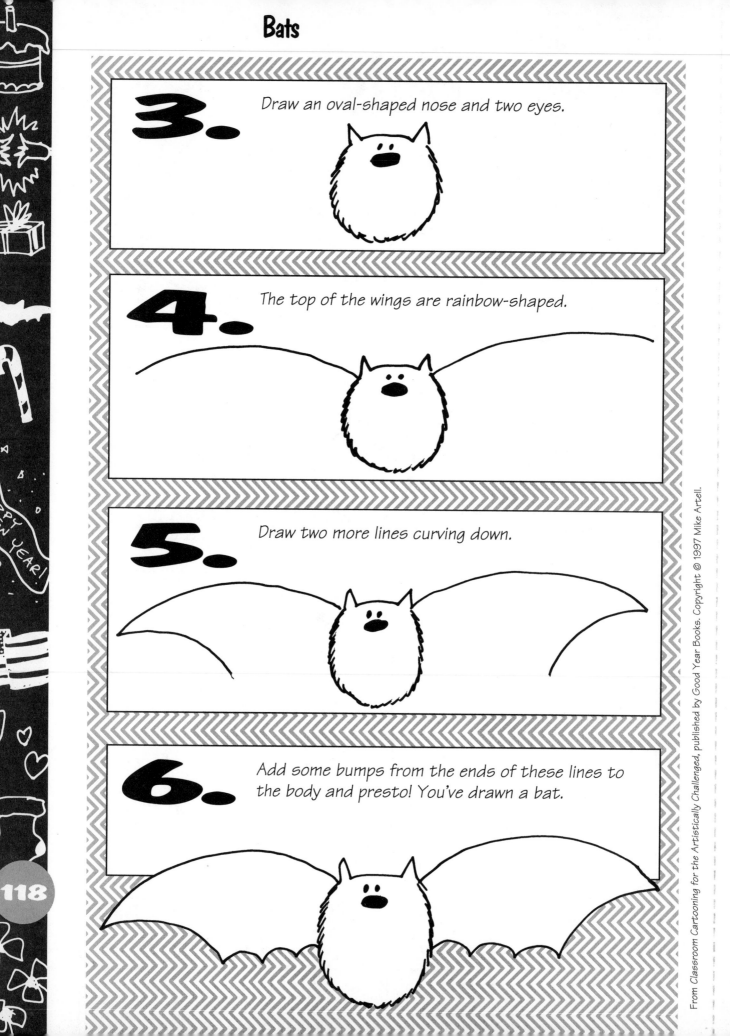

3. Draw an oval-shaped nose and two eyes.

4. The top of the wings are rainbow-shaped.

5. Draw two more lines curving down.

6. Add some bumps from the ends of these lines to the body and presto! You've drawn a bat.

118

From *Classroom Cartooning for the Artistically Challenged*, published by Good Year Books. Copyright © 1997 Mike Artell.

Drawing silhouettes of bats can be very dramatic.

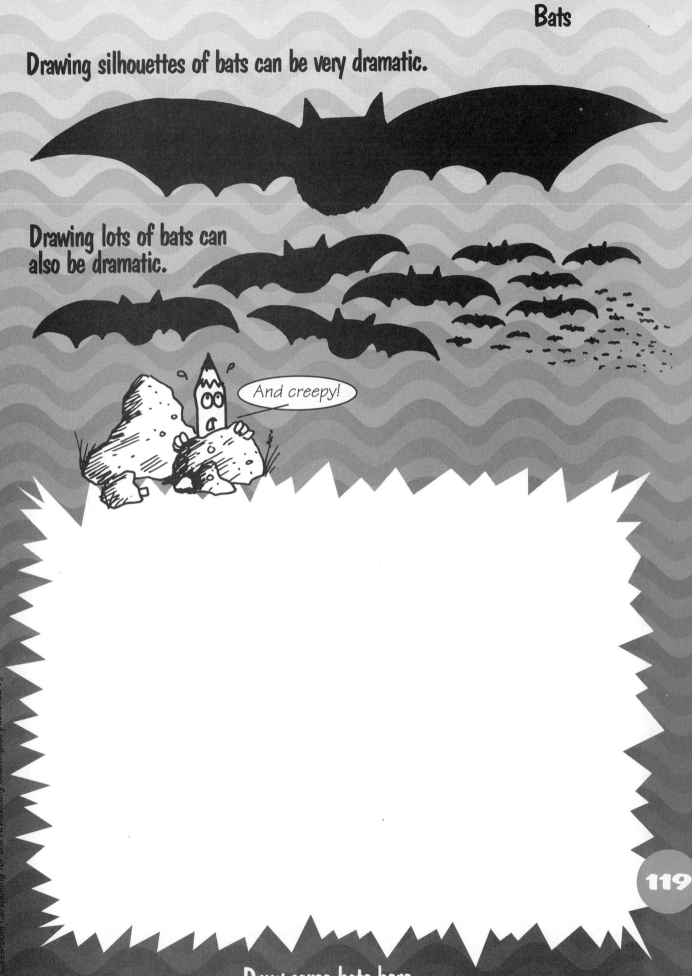

Drawing lots of bats can also be dramatic.

And creepy!

Draw some bats here.

Thanksgiving

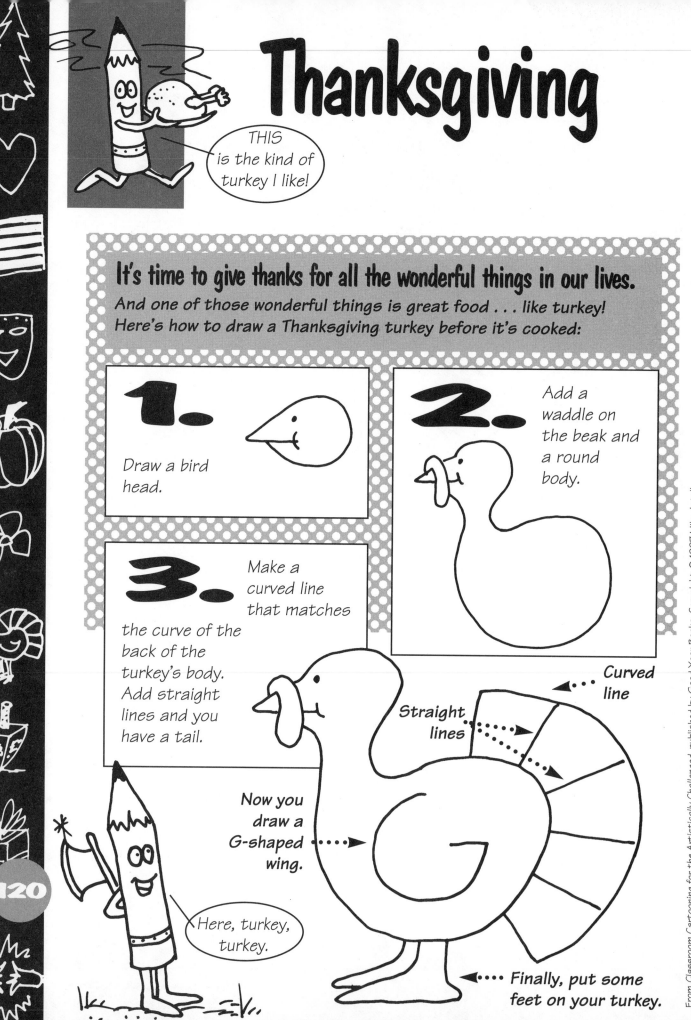

THIS is the kind of turkey I like!

It's time to give thanks for all the wonderful things in our lives.
And one of those wonderful things is great food . . . like turkey!
Here's how to draw a Thanksgiving turkey before it's cooked:

1. Draw a bird head.

2. Add a waddle on the beak and a round body.

3. Make a curved line that matches the curve of the back of the turkey's body. Add straight lines and you have a tail.

Now you draw a G-shaped wing.

Straight lines

Curved line

Here, turkey, turkey.

Finally, put some feet on your turkey.

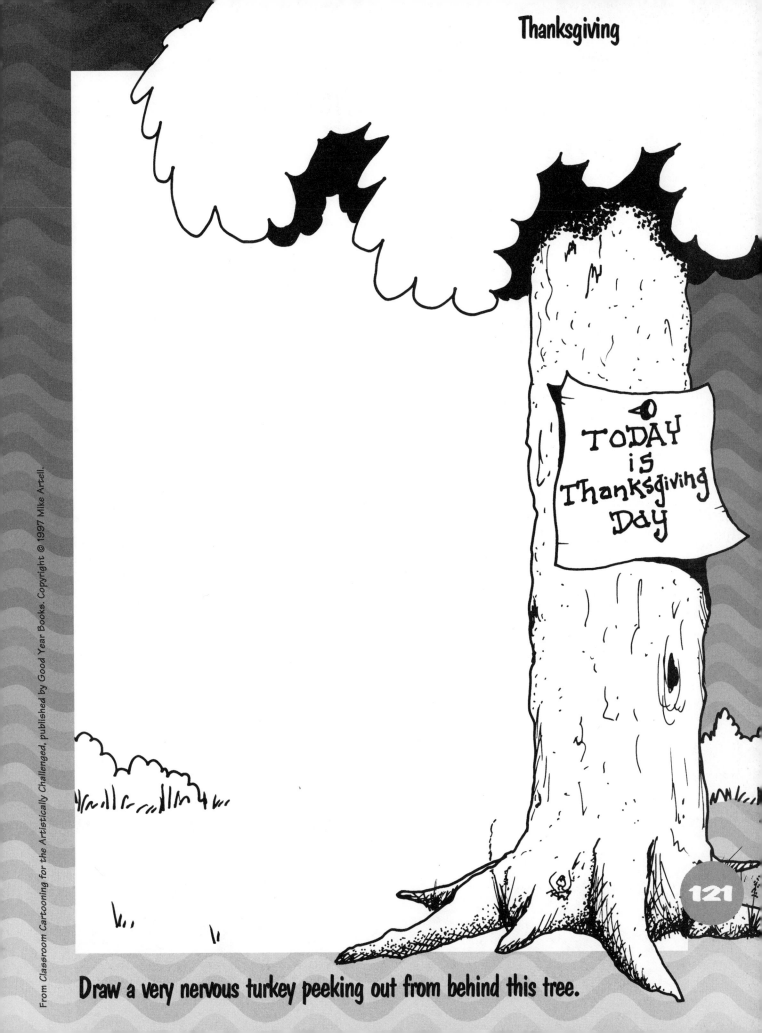

TODAY
iS
Thanksgiving
Day

121

Draw a very nervous turkey peeking out from behind this tree.

Hanukkah

The Jewish Festival of Hanukkah lasts for eight days and usually occurs about the same time of year as Christmas. One of the toys associated with Hannukah is a dreidel, which is a small wooden top. Here's how to draw a dreidel.

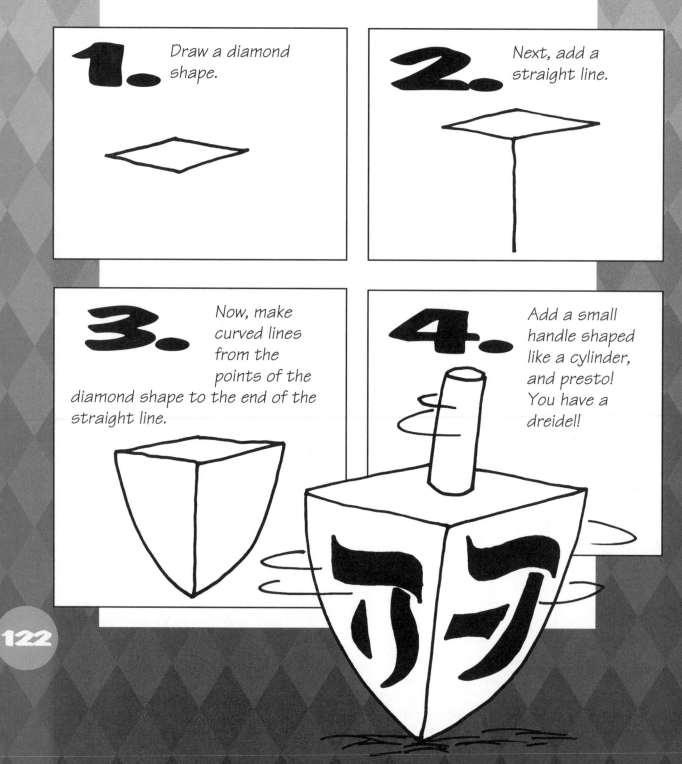

1. Draw a diamond shape.

2. Next, add a straight line.

3. Now, make curved lines from the points of the diamond shape to the end of the straight line.

4. Add a small handle shaped like a cylinder, and presto! You have a dreidel!

From Classroom Cartooning for the Artistically Challenged, published by Good Year Books. Copyright © 1997 Mike Artell.

It's beginning to look a lot like...

Christmas

It's the Night Before Christmas,
And I know that soon
You will be drawing
A Christmas cartoon!

Here's how to draw Santa!

1. Start with a round nose, two dot eyes, and a puffy cloud beard. Add a smile.

2. Now draw two fuzzy rainbow shapes for the brim of the stocking cap. Add shoulders and arms.

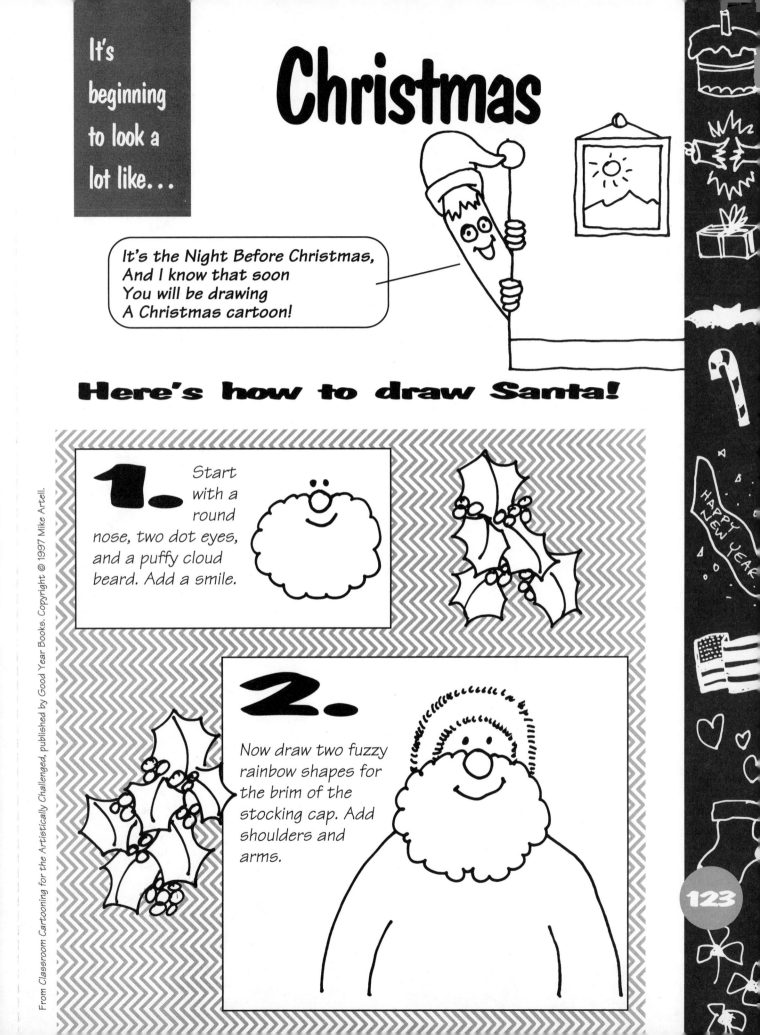

HAPPY NEW YEAR

123

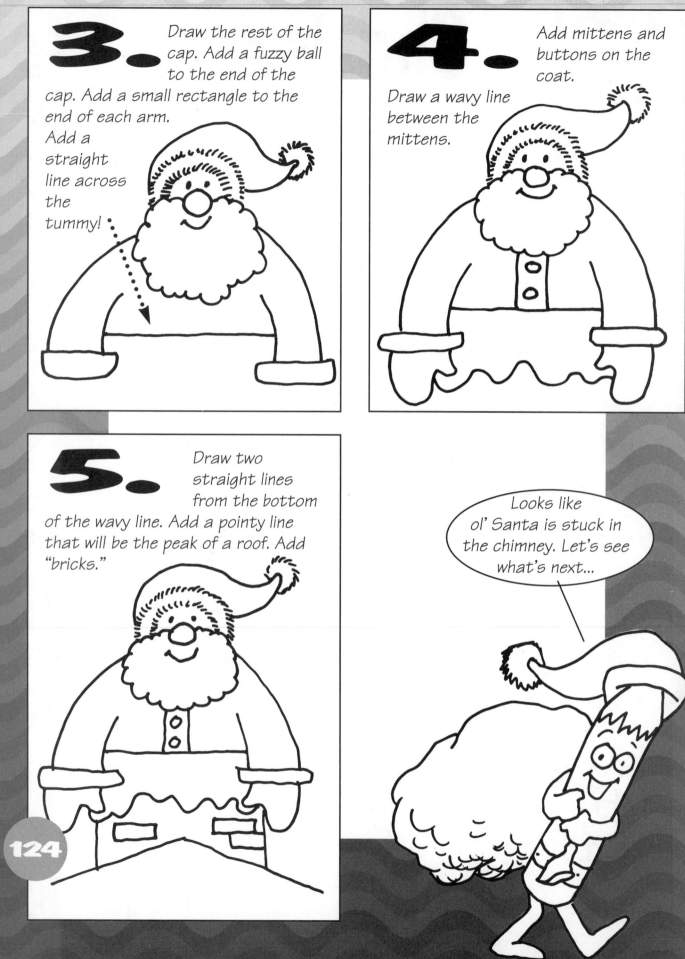

3. Draw the rest of the cap. Add a fuzzy ball to the end of the cap. Add a small rectangle to the end of each arm. Add a straight line across the tummy!

4. Add mittens and buttons on the coat. Draw a wavy line between the mittens.

5. Draw two straight lines from the bottom of the wavy line. Add a pointy line that will be the peak of a roof. Add "bricks."

Looks like ol' Santa is stuck in the chimney. Let's see what's next...

124

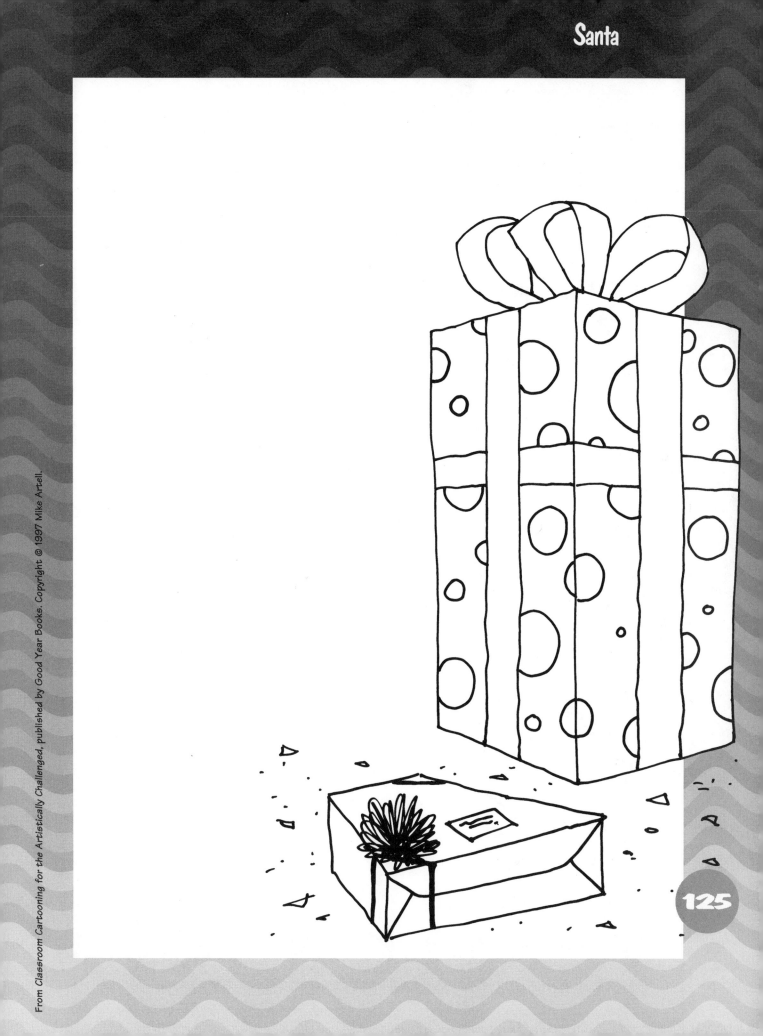

Christmas Trees

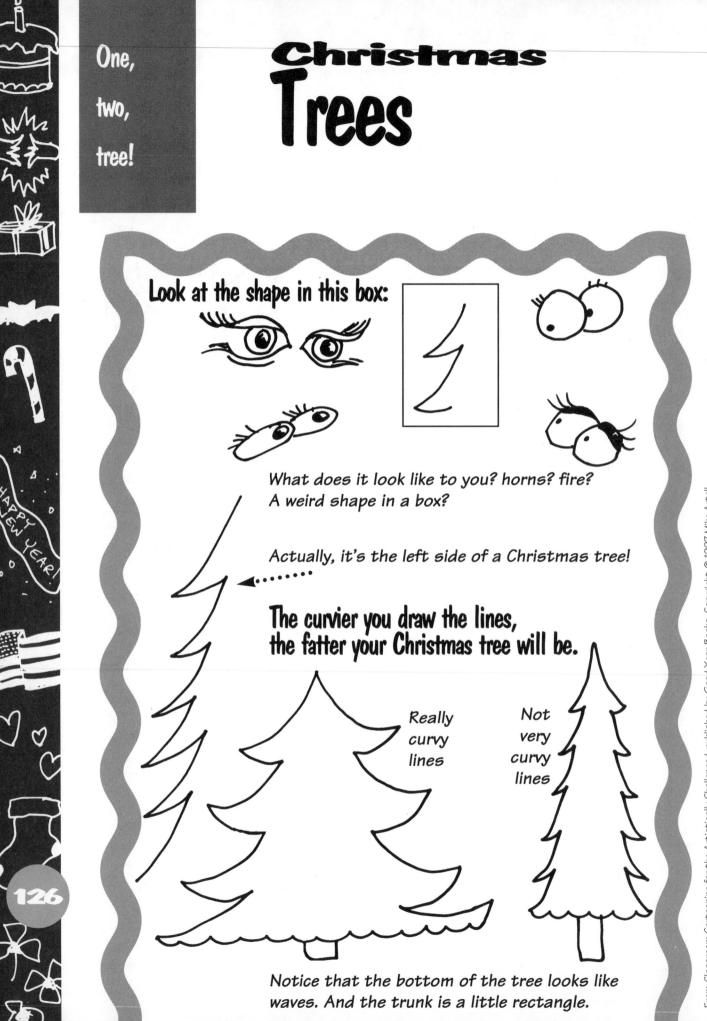

Look at the shape in this box:

What does it look like to you? horns? fire?
A weird shape in a box?

Actually, it's the left side of a Christmas tree!

**The curvier you draw the lines,
the fatter your Christmas tree will be.**

Really
curvy
lines

Not
very
curvy
lines

Notice that the bottom of the tree looks like
waves. And the trunk is a little rectangle.

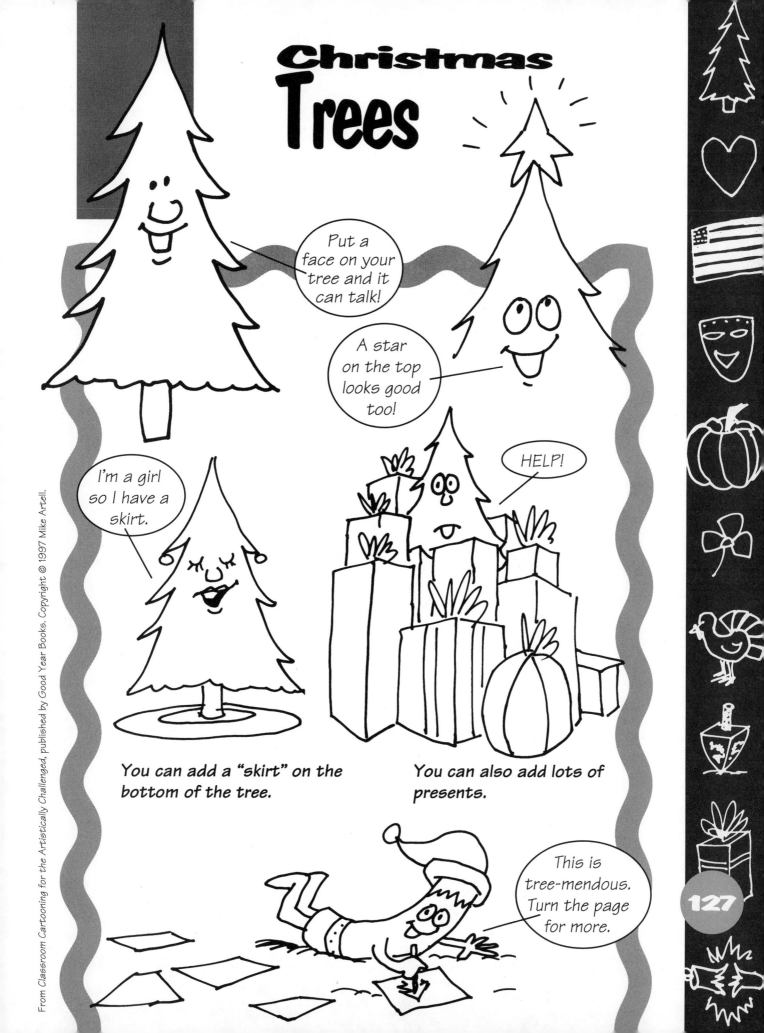

Christmas Trees

Put a face on your tree and it can talk!

A star on the top looks good too!

I'm a girl so I have a skirt.

HELP!

You can add a "skirt" on the bottom of the tree.

You can also add lots of presents.

This is tree-mendous. Turn the page for more.

127

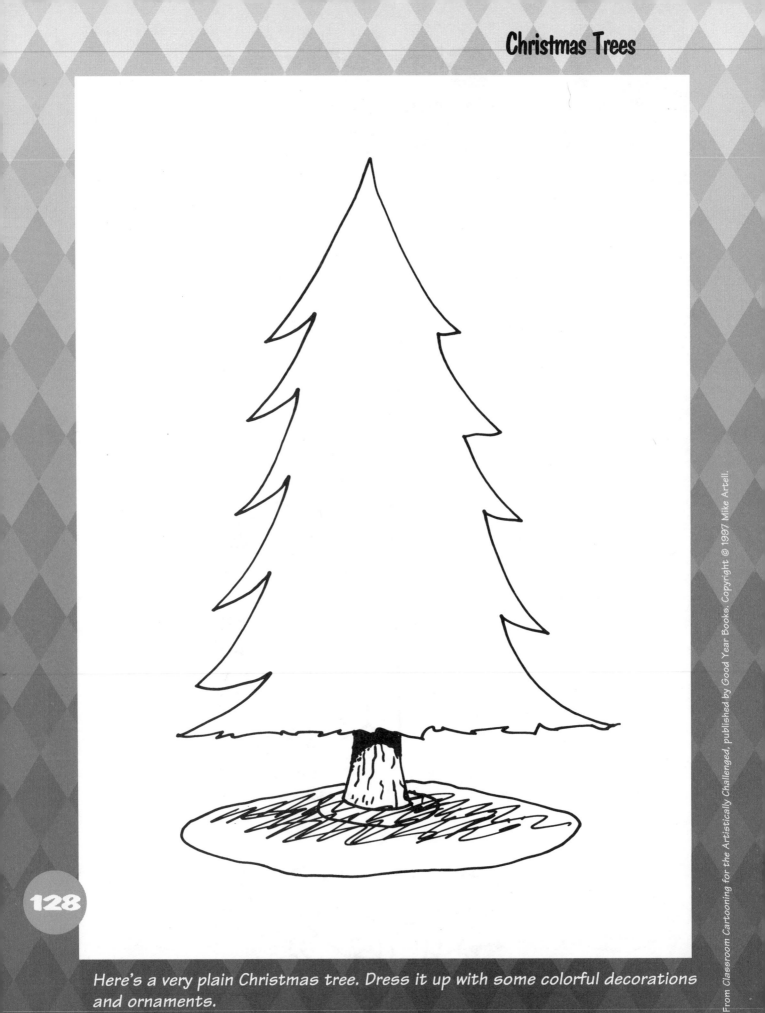

Here's a very plain Christmas tree. Dress it up with some colorful decorations and ornaments.

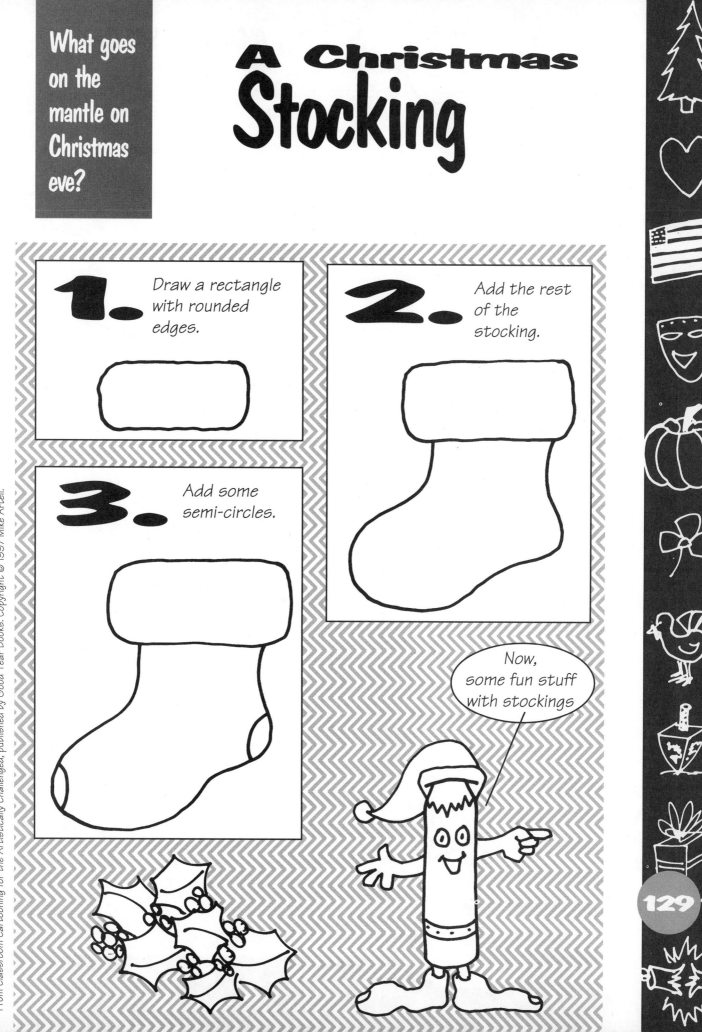

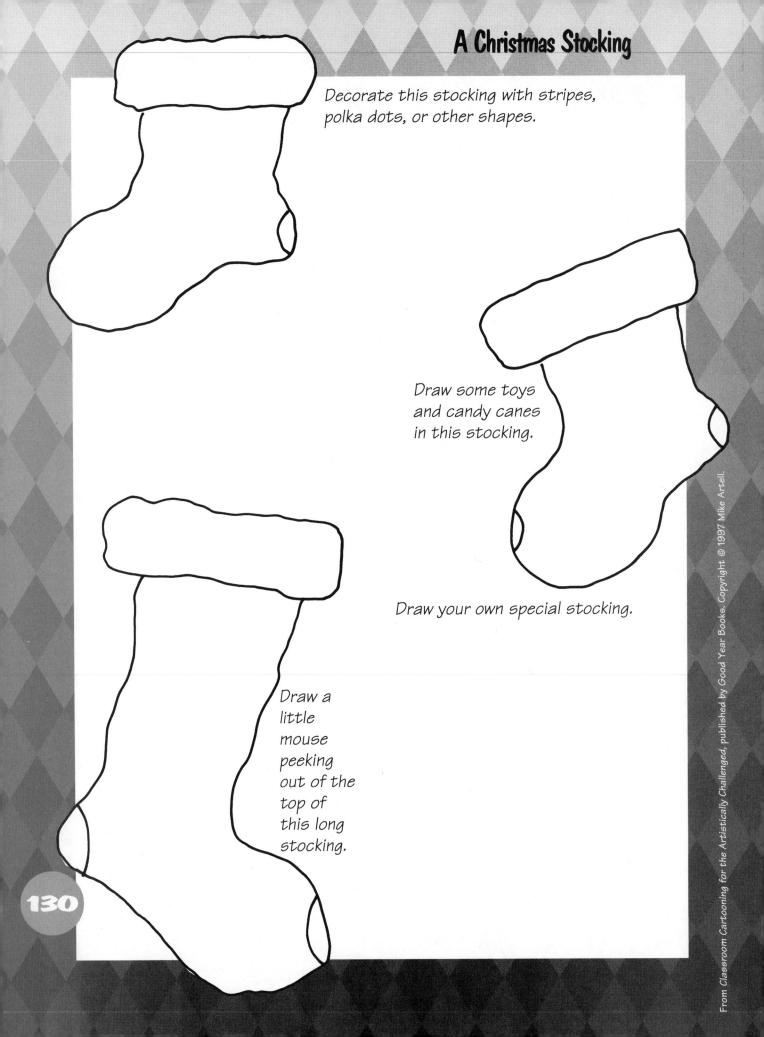

Decorate this stocking with stripes, polka dots, or other shapes.

Draw some toys and candy canes in this stocking.

Draw your own special stocking.

Draw a little mouse peeking out of the top of this long stocking.

130

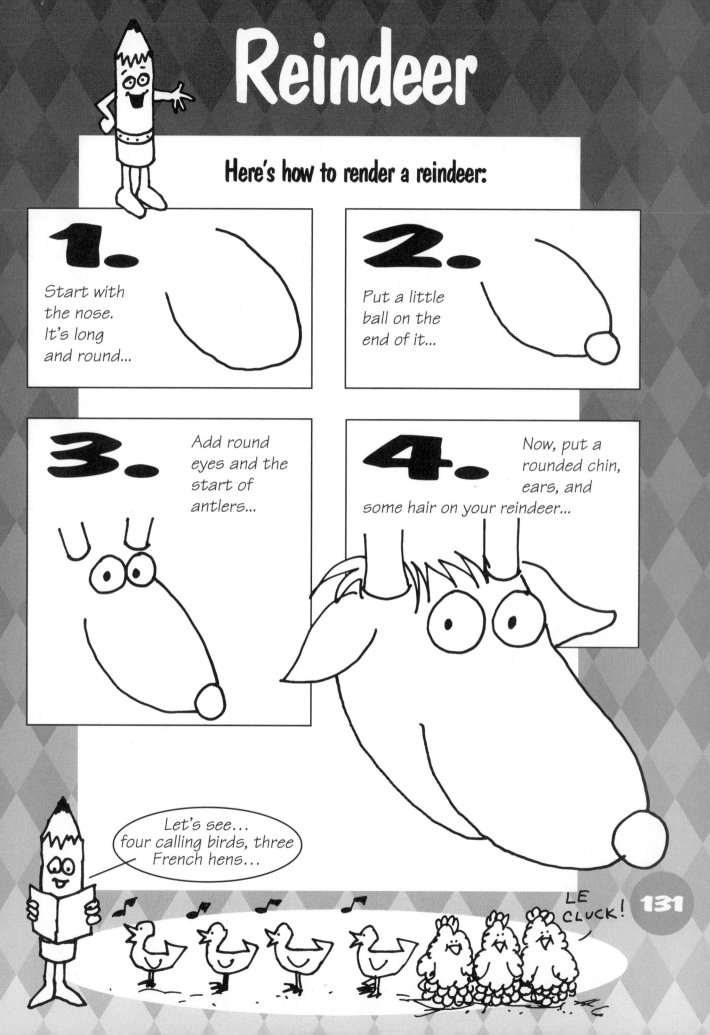

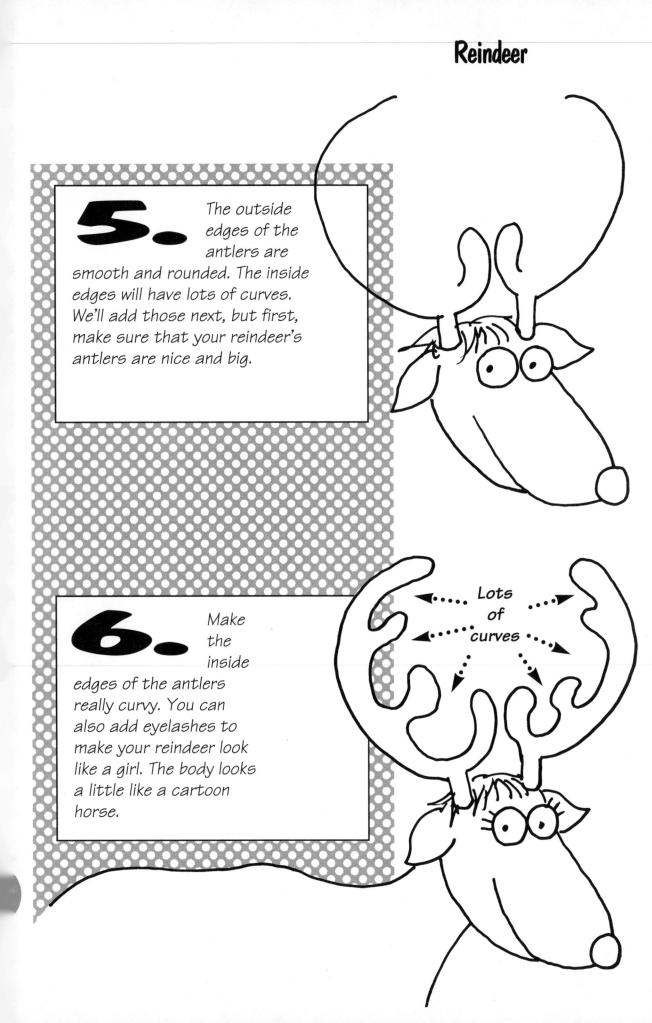

5. The outside edges of the antlers are smooth and rounded. The inside edges will have lots of curves. We'll add those next, but first, make sure that your reindeer's antlers are nice and big.

6. Make the inside edges of the antlers really curvy. You can also add eyelashes to make your reindeer look like a girl. The body looks a little like a cartoon horse.

Lots of curves

Draw some funny antlers on this reindeer.

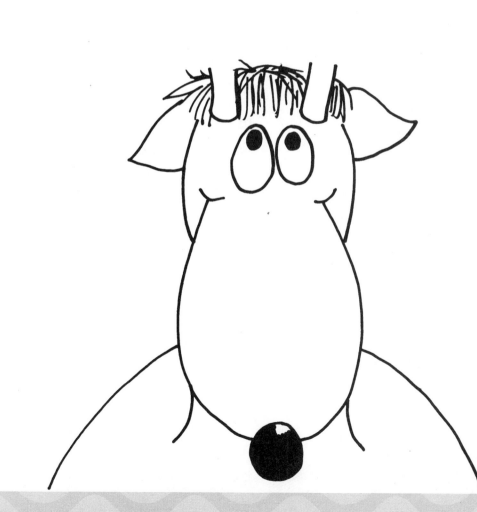

Think Funny!

To make some funny Christmas cartoons, think about "before and after" ideas. For example: Draw some Christmas trees talking to each other before they are decorated. Or try drawing the same trees talking to each other as they lay in a pile after Christmas is over.

Draw Santa before Christmas, all excited and busy. Then draw Santa the day after Christmas when he's pooped. Other before/after ideas might include snowmen, elves, reindeer, and toys.

From Classroom Cartooning for the Artistically Challenged, published by Good Year Books. Copyright © 1997 Mike Artell.

Kwanza

Kwanza is a celebration that begins on December 26 and continues through January 1.

Kwanza has seven principles, each of which is celebrated on one of these seven days.

The sixth principle is Kuumba, or creativity. One way to celebrate this principle is by writing a song or by making an African mask.

Here are some ideas for masks:

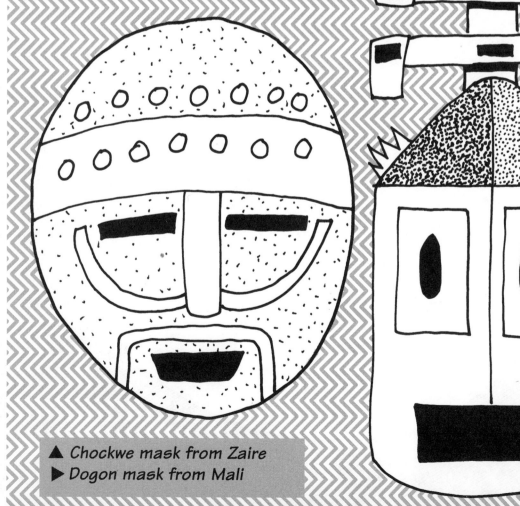

▲ Chockwe mask from Zaire
▶ Dogon mask from Mali

Here is a mask for you to design. Be sure to color it too!

From *Classroom Cartooning for the Artistically Challenged*, published by Good Year Books. Copyright © 1997 Mike Artell.

New Year's Day

January 1 is the start of a brand new year. That's why people often draw the new year as a newborn baby. Here's how to draw one version of the new year baby.

1.

Draw a round head, eyes and a mouth. Be sure to draw everything below the middle of the head. Add a tiny nose and small ears.

2.

The arms come out of the head. Don't draw a neck. Add "pudgy" fingers. The tummy is round. Draw a little curly hair too.

137

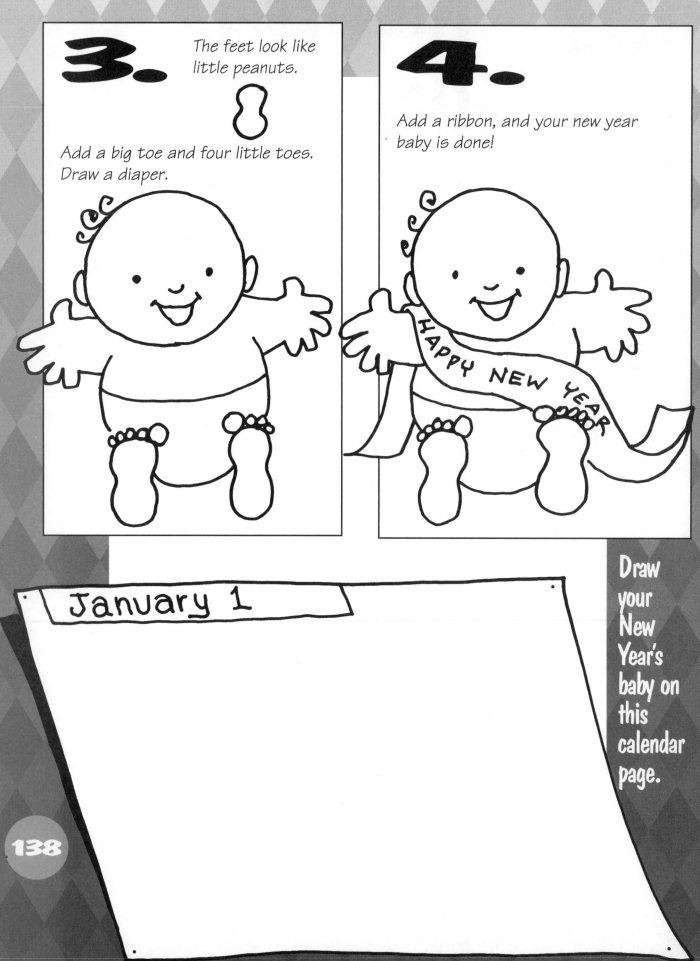

3. The feet look like little peanuts.

Add a big toe and four little toes. Draw a diaper.

4. Add a ribbon, and your new year baby is done!

HAPPY NEW YEAR

January 1

Draw your New Year's baby on this calendar page.

138

Groundhog Day

It's not Woodchuck Day, it's not Whistle Pig Day, it's...

Tradition says that you can predict how much longer winter will last by watching what a groundhog does on February 2. If it comes out of its hole and stays out, winter will soon end. If it sees its shadow and runs back into its hole, winter will last six more weeks. Let's draw some groundhogs.

1. Begin by drawing an oval nose, round head, round ear, and a dot eye. Add two rodent teeth.

2. Add a curvy back and chest. Draw some pointy claws in front.

3. Now your groundhog needs a round backside and a bushy tail. Draw some pointy claws on the back and front feet.

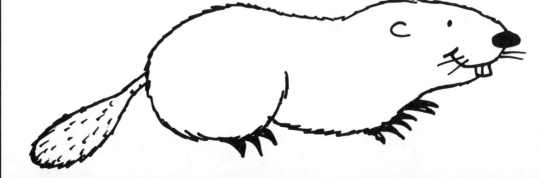

This is how a groundhog looks peeking out of its burrow.

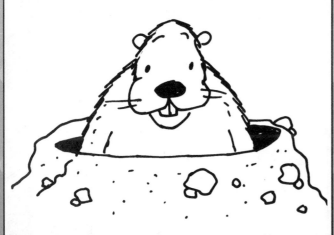

Here's the face of a frightened groundhog!

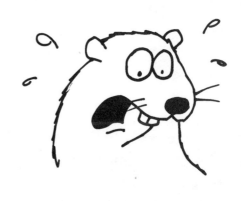

In this space, draw a groundhog who has seen its shadow.

From *Classroom Cartooning for the Artistically Challenged*, published by Good Year Books. Copyright © 1997 Mike Artell.

Valentine's Day

Just about everybody knows how to draw a valentine heart. Here's how to draw two valentine "love birds."

1. Draw a circle head with a pointy beak on one side. Add a rainbow-shaped eye.

2. Draw a body that looks like a piece of watermelon. Add another little piece of watermelon for the tail.

Draw a smiley-face wing.

3. The last thing to draw are the legs and feet. Simply draw four straight lines and add some pointy shapes at the bottom like this:

Straight lines •••••▶

Pointy shapes •••••▶

141

4.

Now, draw the same exact bird pointing the other way. Make their beaks touch, and you have two lovebirds kissing.

Try drawing two lovebirds here.

St. Patrick's Day

If you've got the luck of the Irish, you may be lucky enough to see a leprechaun. But just in case you don't see one, you may want to know how to draw one. Here's a simple way to do it.

1. Start with the funny hat. It looks a little like an upside-down bucket with a brim. Draw a smiling face and some whiskers.

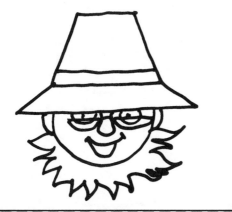

2. Now draw some little half-glasses on your leprechaun. Add some arms and hands. These hands will be holding a big pot of gold.

143

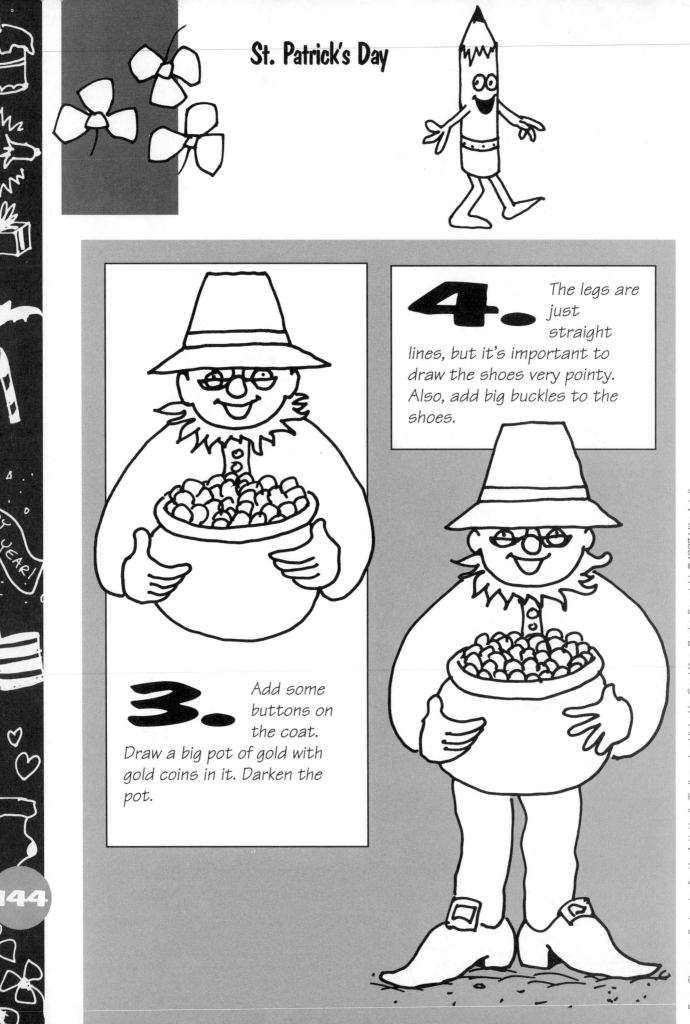

St. Patrick's Day

4. The legs are just straight lines, but it's important to draw the shoes very pointy. Also, add big buckles to the shoes.

3. Add some buttons on the coat. Draw a big pot of gold with gold coins in it. Darken the pot.

144

From *Classroom Cartooning for the Artistically Challenged*, published by Good Year Books. Copyright © 1997 Mike Artell.

Here's the end of a rainbow. Draw a leprechaun and his pot of gold.

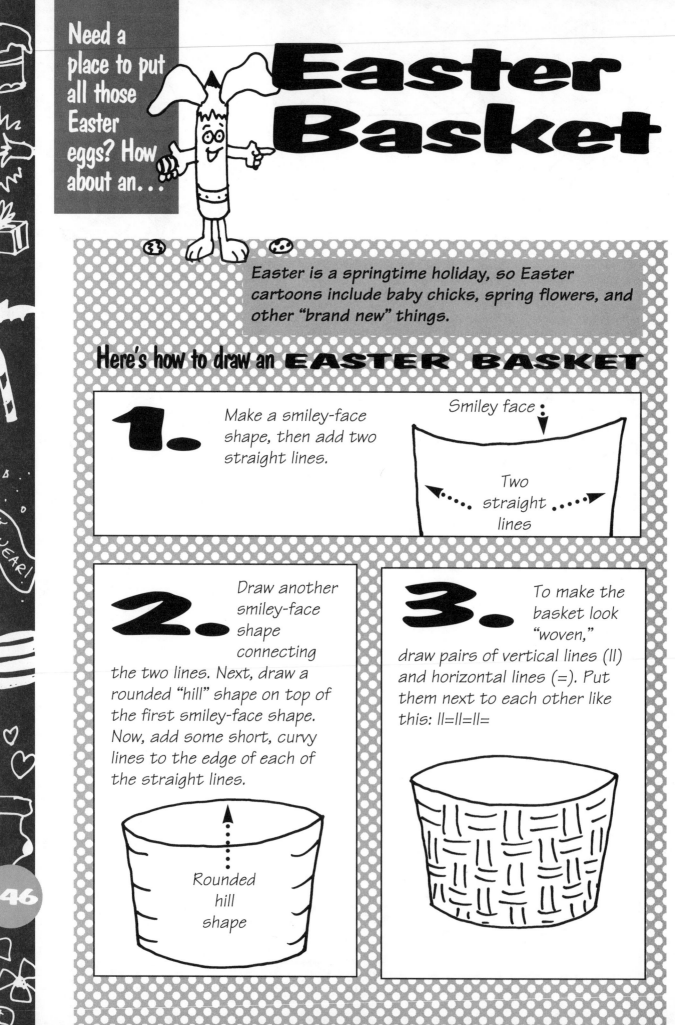

Need a place to put all those Easter eggs? How about an...

Easter Basket

Easter is a springtime holiday, so Easter cartoons include baby chicks, spring flowers, and other "brand new" things.

Here's how to draw an EASTER BASKET

1. Make a smiley-face shape, then add two straight lines.

Smiley face

Two straight lines

2. Draw another smiley-face shape connecting the two lines. Next, draw a rounded "hill" shape on top of the first smiley-face shape. Now, add some short, curvy lines to the edge of each of the straight lines.

Rounded hill shape

3. To make the basket look "woven," draw pairs of vertical lines (ll) and horizontal lines (=). Put them next to each other like this: ll=ll=ll=

146

From Classroom Cartooning for the Artistically Challenged, published by Good Year Books. Copyright © 1997 Mike Artell.

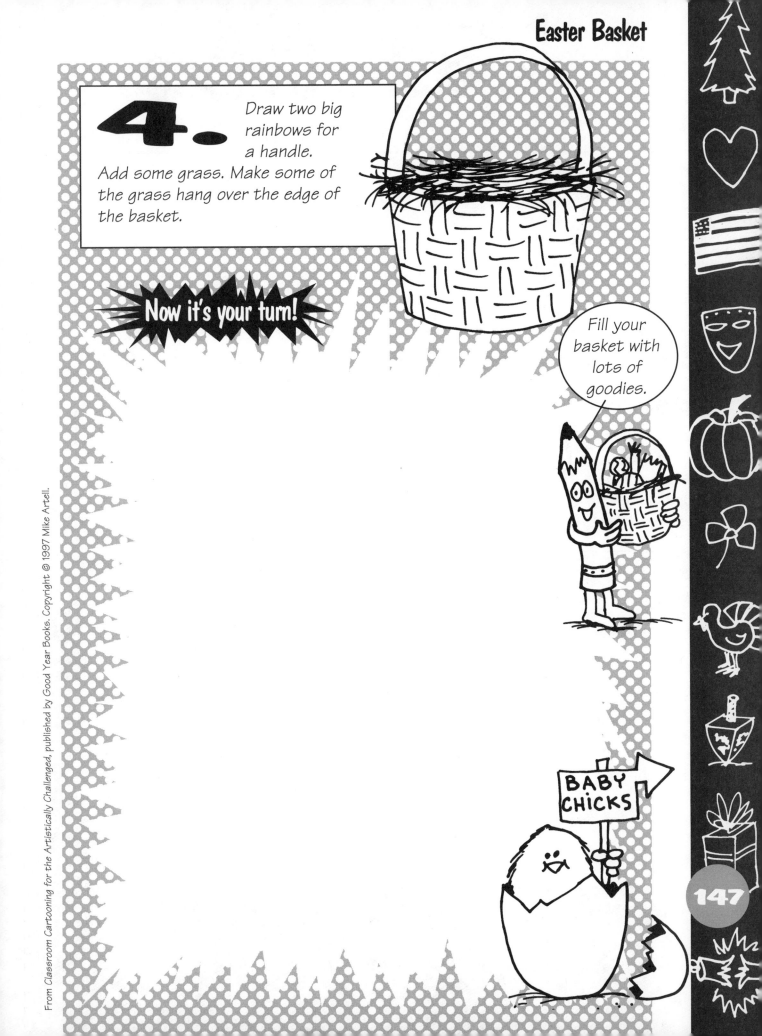

Easter Basket

4. Draw two big rainbows for a handle. Add some grass. Make some of the grass hang over the edge of the basket.

Now it's your turn!

Fill your basket with lots of goodies.

BABY CHICKS

Baby Chicks

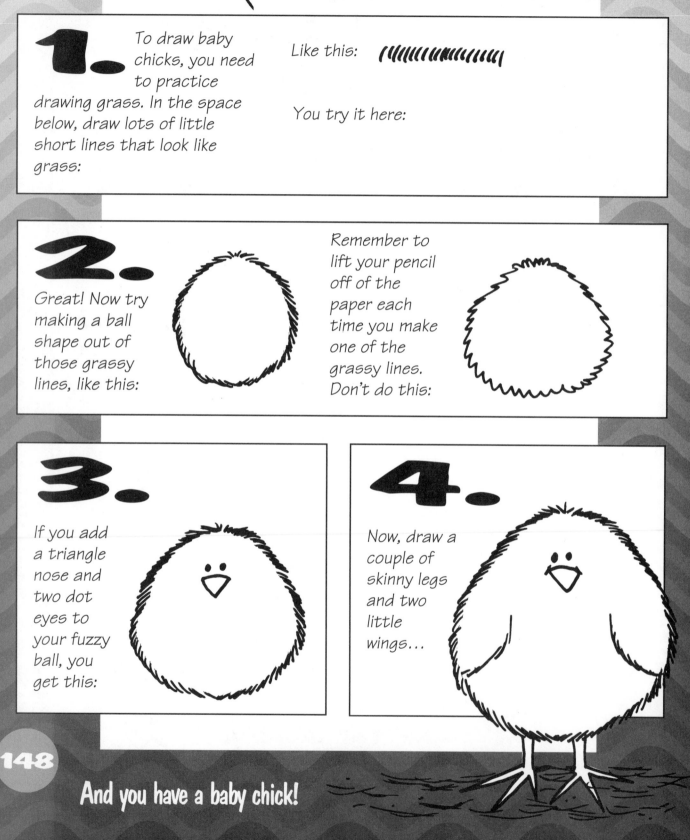

1. To draw baby chicks, you need to practice drawing grass. In the space below, draw lots of little short lines that look like grass:

Like this:

You try it here:

2. Great! Now try making a ball shape out of those grassy lines, like this:

Remember to lift your pencil off of the paper each time you make one of the grassy lines. Don't do this:

3. If you add a triangle nose and two dot eyes to your fuzzy ball, you get this:

4. Now, draw a couple of skinny legs and two little wings…

And you have a baby chick!

148

From *Classroom Cartooning for the Artistically Challenged,* published by Good Year Books. Copyright © 1997 Mike Artell.

Move the face around the body and you can create lots of baby chicks...FUN!

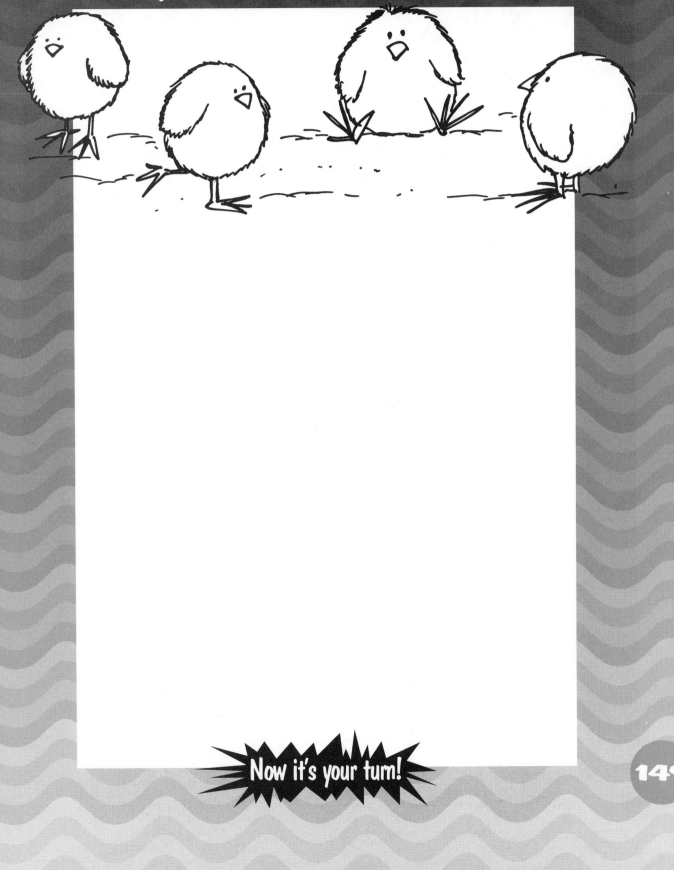

Now it's your turn!

Flowers

Easter means spring and spring means new flowers poking their heads out of the ground. Here are some ways to draw spring flowers:

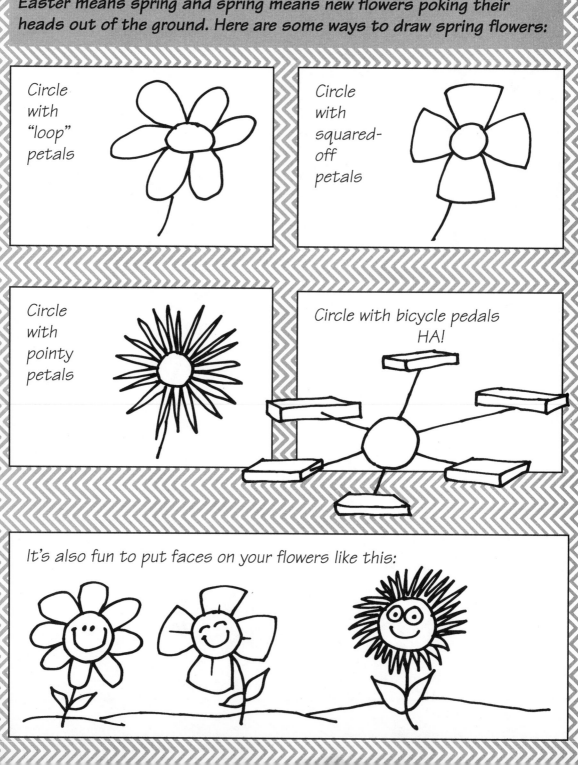

Circle with "loop" petals

Circle with squared-off petals

Circle with pointy petals

Circle with bicycle pedals HA!

It's also fun to put faces on your flowers like this:

From *Classroom Cartooning for the Artistically Challenged*, published by Good Year Books. Copyright © 1997 Mike Artell.

Below are some flower stems. Draw flowers to go with the stems:

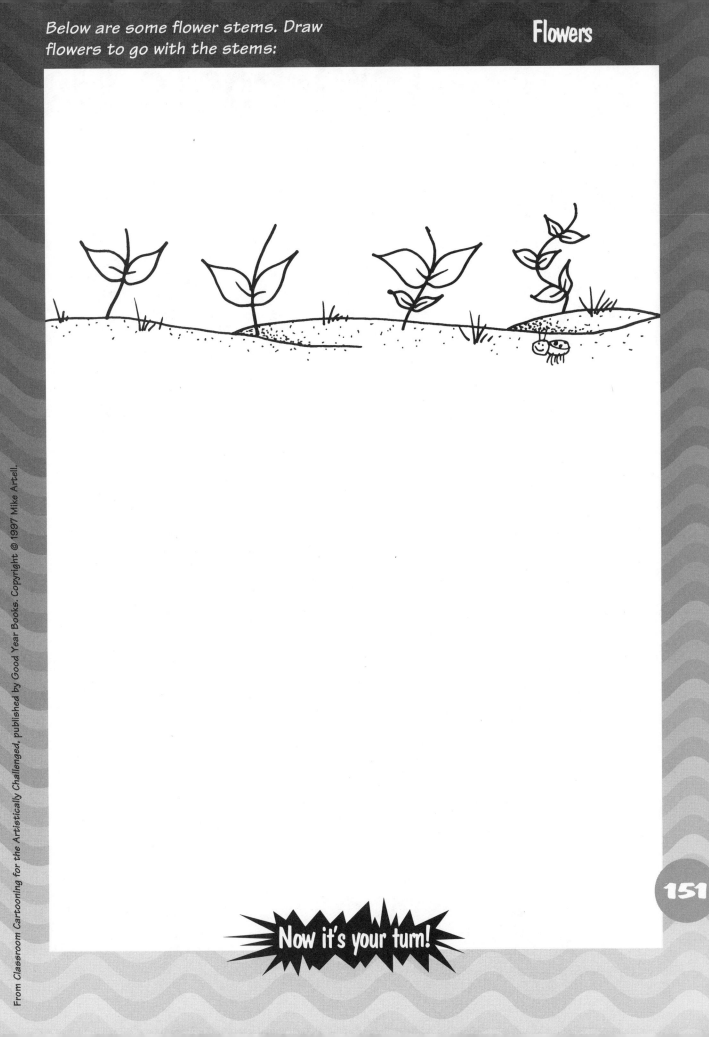

Now it's your turn!

April Fool's Day

This is the world's funniest day.

Everybody is playing jokes on each other! Here is an April Fool's idea for you to draw:

Remember how you drew the Easter spring flowers? Good! Just draw one of those flowers on somebody's coat and have it squirting water at someone else. It's a great April Fool's joke.

From *Classroom Cartooning for the Artistically Challenged*, published by Good Year Books. Copyright © 1997 Mike Artell.

Think Funny!

Draw a cartoon of someone playing an April Fool joke on someone else. Remember, April Fool's Day is supposed to be fun, not mean. Be sure that the ideas you draw would be fun for everyone involved.

Here's another idea. Use this space to write down some funny April Fool's things to tell your friends and family on April Fool's Day.

For instance, you could wake your brother or sister up and say, "Guess what? I read in the paper that school is called off this morning!" Give them a second or two to get excited, then say, "April Fool!" Get the idea?

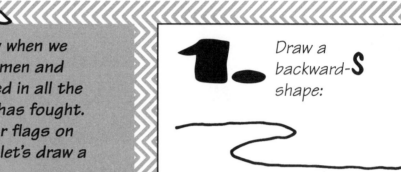

Memorial Day

This is the day when we remember the men and women who died in all the wars America has fought. Since we fly our flags on Memorial Day, let's draw a flag.

1. Draw a backward-**S** shape:

2. Add straight lines at each curve and at the ends of the curvy line:

Make this line a little shorter.

3. Connect the straight lines with two more curved lines.

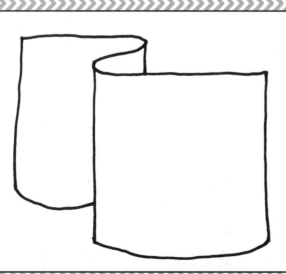

154

From *Classroom Cartooning for the Artistically Challenged*, published by Good Year Books. Copyright © 1997 Mike Artell.

Add stars and stripes to your flag.

And add a flag pole.

Here's a spot for you to draw your own flag:

Fourth of July

It's time for picnics, parades, and patriotism. It's the Fourth of July! Here are some Fourth of July cartoons you can draw. Let's start with a bang and draw a firecracker:

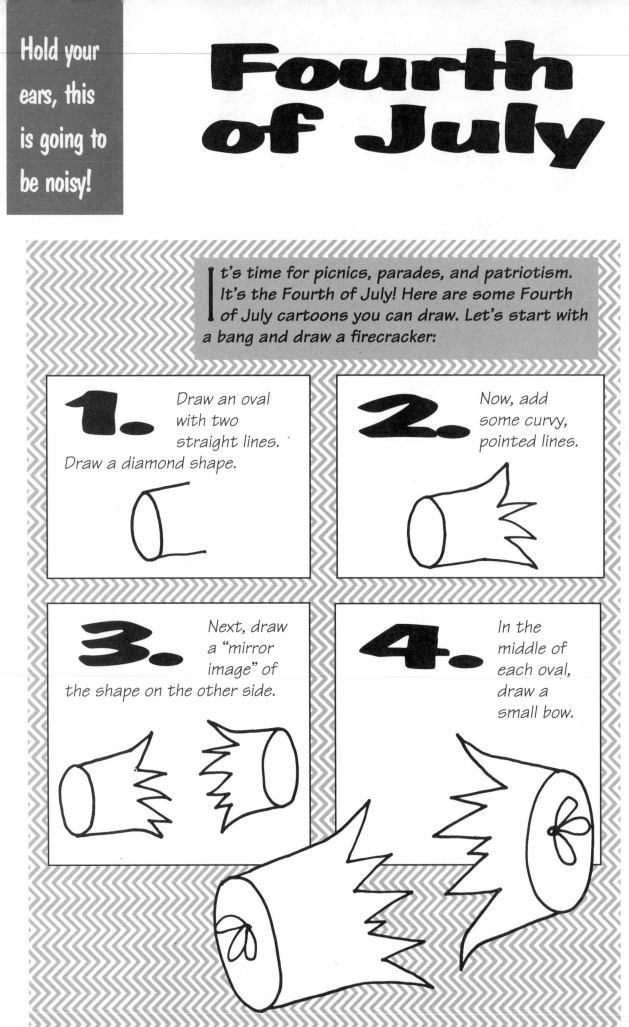

1. Draw an oval with two straight lines. Draw a diamond shape.

2. Now, add some curvy, pointed lines.

3. Next, draw a "mirror image" of the shape on the other side.

4. In the middle of each oval, draw a small bow.

156

From *Classroom Cartooning for the Artistically Challenged*, published by Good Year Books. Copyright © 1997 Mike Artell.

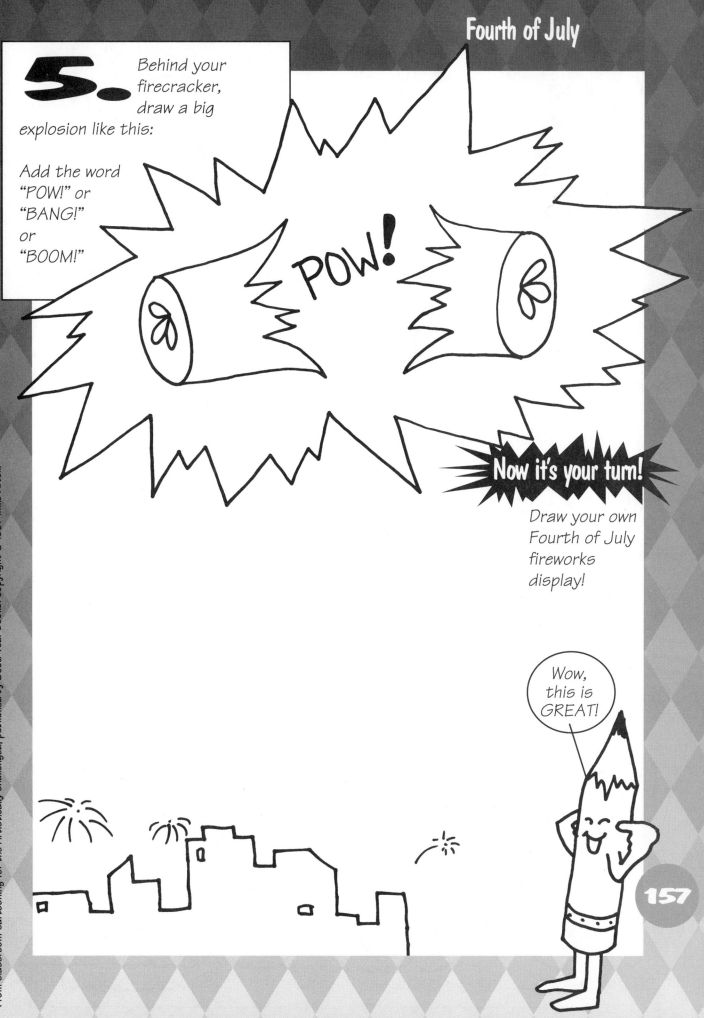

5. Behind your firecracker, draw a big explosion like this:

Add the word "POW!" or "BANG!" or "BOOM!"

POW!

Now it's your turn!

Draw your own Fourth of July fireworks display!

Wow, this is GREAT!

Fourth of July

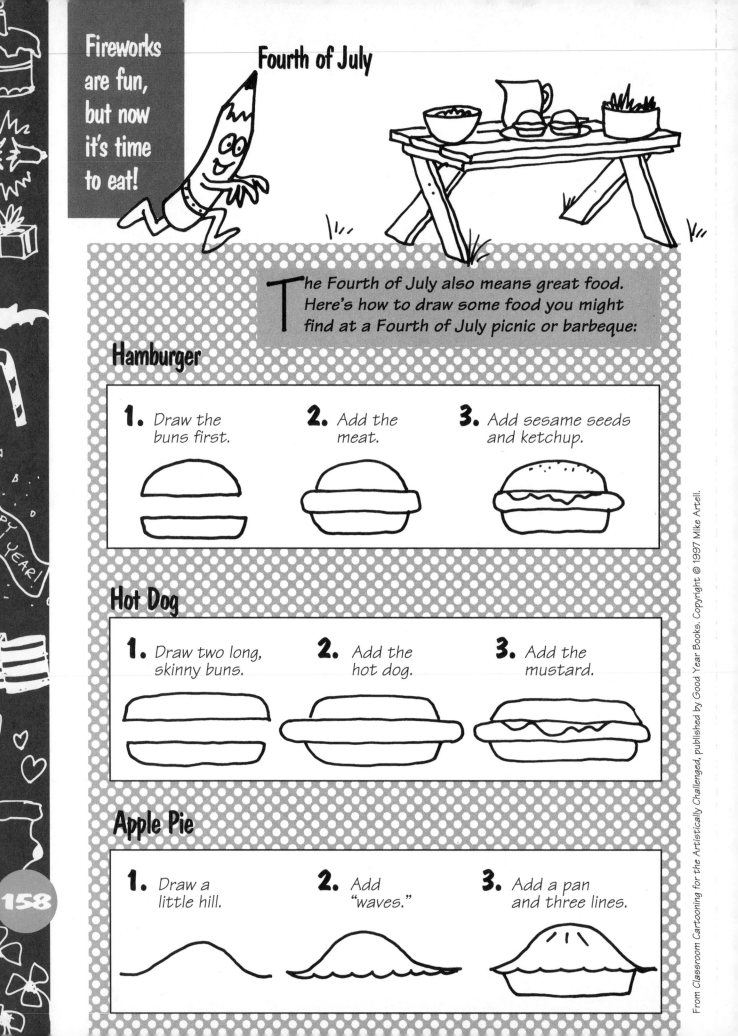

T he Fourth of July also means great food. Here's how to draw some food you might find at a Fourth of July picnic or barbeque:

Hamburger

1. Draw the buns first.

2. Add the meat.

3. Add sesame seeds and ketchup.

Hot Dog

1. Draw two long, skinny buns.

2. Add the hot dog.

3. Add the mustard.

Apple Pie

1. Draw a little hill.

2. Add "waves."

3. Add a pan and three lines.

159

This hungry guy is about to eat something good. In his hand, draw a hamburger, a piece of pie, or something else to eat.

Use Your Cartooning Skills

✏️ Draw the character or object (we're using animals here) directly onto Pelon® fabric and create flannelboard characters.

✏️ Tape butcher paper to the wall. Create a zoo by labeling different areas for different animals. Have the children draw animals and place them in the appropriate areas.

✏️ Draw animals, and then draw caption balloons containing the sound the animal makes (such as moo, quack, or meow). With scissors, cut out the animal drawings and the caption balloons. Encourage small children to match the animal with the sound it makes.

160

From *Classroom Cartooning for the Artistically Challenged*, published by Good Year Books. Copyright © 1997 Mike Artell.

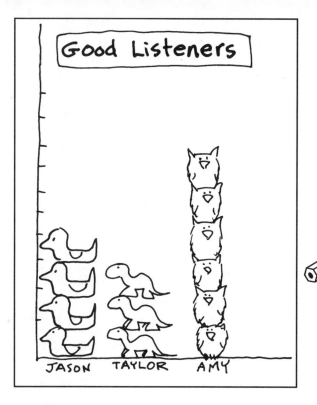

✏️ Draw animals, photocopy the drawings several times, and use them to make graphs. Hint: If you reduce the drawings, then paste lots of them onto the page before copying again, you can create lots of critters per copy.

✏️ Draw animals, or have children draw animals. Then cut them out and sort them by habitat. Examples: A walrus, polar bear, and reindeer are all cold-weather animals. Parrots and lions (but not necessarily tigers) are warm-weather animals. Sort by other characteristics: color, size, meat eaters/vegetarians, dangerous/friendly, and so on.

✏️ Be creative! Draw really weird creatures that are combinations of several different animals. Make up stories about each weird animal. Encourage the children to create data sheets explaining what the weird animals eat, where they live, what sounds they make, and so on.

Cartoon Strips

MOVE THE CAMERA!!

Here's what a cartoon strip looks like when you keep the "camera" in one spot...

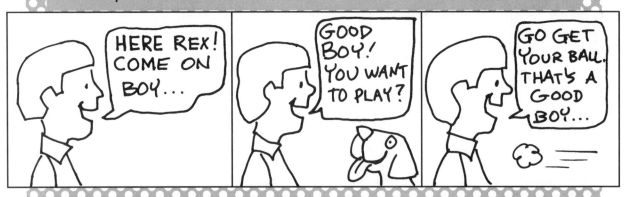

HERE REX! COME ON BOY...

GOOD BOY! YOU WANT TO PLAY?

GO GET YOUR BALL. THAT'S A GOOD BOY...

Let's try "moving the camera" around so we can get a different look at our characters.

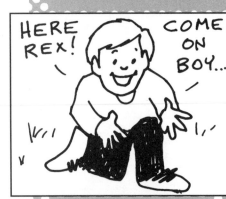

HERE REX! COME ON BOY...

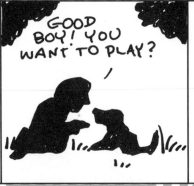

GOOD BOY! YOU WANT TO PLAY?

GO GET YOUR BALL. THAT'S A GOOD BOY...

Close-up of a boy—we can see his whole body.

Silhouette of boy and dog—the "camera" is pulled back.

Close-up of a dog only—"camera" moves in. Boy's words come from outside the panel.

TIP: Move the "camera" around. Show some characters up close, then "pull back" and draw them as if they were far away. Draw them as silhouettes. Draw them from the front, from the side and from the back. Keep the "camera" moving!

162

From Classroom Cartooning for the Artistically Challenged, published by Good Year Books. Copyright © 1997 Mike Artell.

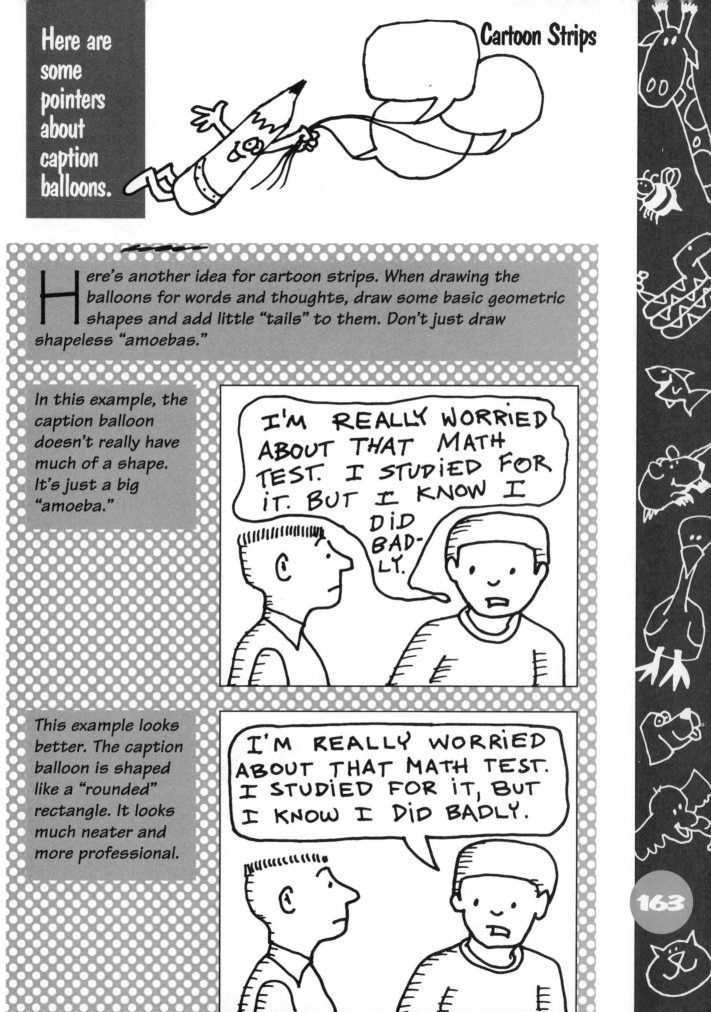

Here are some pointers about caption balloons.

Cartoon Strips

Here's another idea for cartoon strips. When drawing the balloons for words and thoughts, draw some basic geometric shapes and add little "tails" to them. Don't just draw shapeless "amoebas."

In this example, the caption balloon doesn't really have much of a shape. It's just a big "amoeba."

I'M REALLY WORRIED ABOUT THAT MATH TEST. I STUDIED FOR IT. BUT I KNOW I DID BADLY.

This example looks better. The caption balloon is shaped like a "rounded" rectangle. It looks much neater and more professional.

I'M REALLY WORRIED ABOUT THAT MATH TEST. I STUDIED FOR IT, BUT I KNOW I DID BADLY.

Cartoon Strips

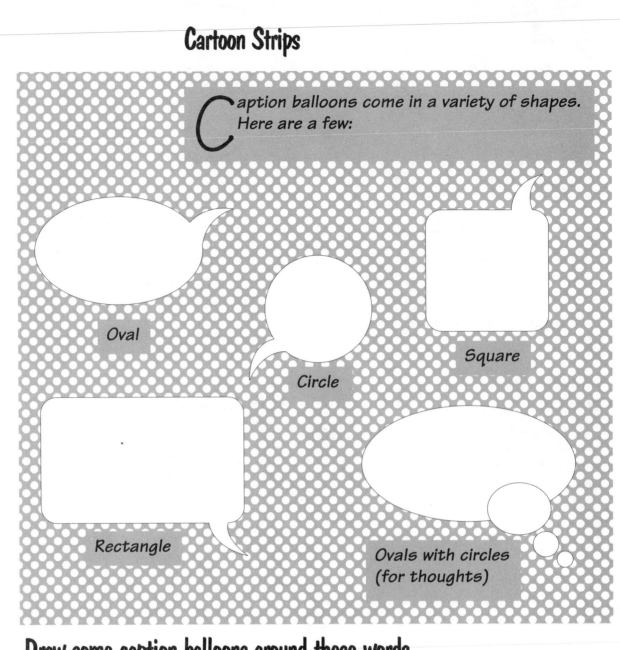

C aption balloons come in a variety of shapes. Here are a few:

Oval

Circle

Square

Rectangle

Ovals with circles (for thoughts)

Draw some caption balloons around these words.

Well, look who decided to join the party.

Hello, I'm Christine.

I wonder what I should do!

Here are some pointers about caption balloons.

Here's another idea for cartoon strips. When drawing the balloons for words and thoughts, draw some basic geometric shapes and add little "tails" to them. Don't just draw shapeless "amoebas."

In this example, the caption balloon doesn't really have much of a shape. It's just a big "amoeba."

This example looks better. The caption balloon is shaped like a "rounded" rectangle. It looks much neater and more professional.

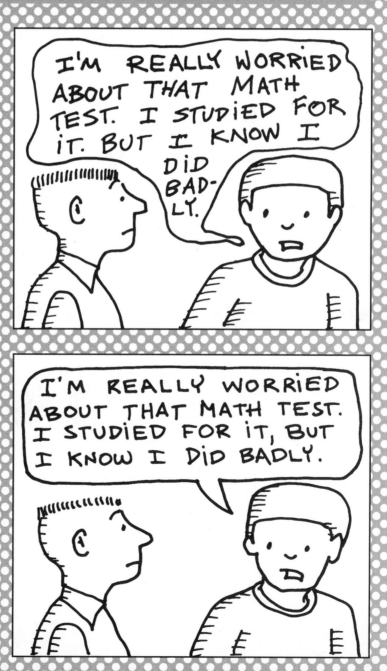

Cartoon Strips

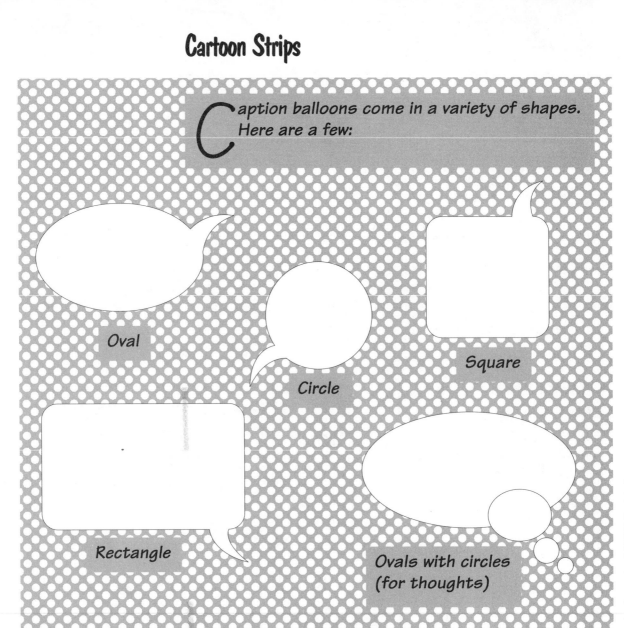

Caption balloons come in a variety of shapes. Here are a few:

Oval

Circle

Square

Rectangle

Ovals with circles (for thoughts)

Draw some caption balloons around these words.

Well, look who decided to join the party.

NO!

Hello, I'm Christine.

I wonder what I should do!

From Classroom Cartooning for the Artistically Challenged, published by Good Year Books. Copyright © 1997 Mike Artell.

Think Funny!

In the space, draw one of the following cartoons:

1. A veterinarian telling an elephant, "of course you itch. You have poison ivory."

2. Two monsters taking a test. One monster has a pair of eyes on top of his test paper. The monster teacher tells the other monster to keep his eyes on his own paper.

3. One pencil asks another pencil, "What state has the most pencils?" The other pencil answers, "Pencil-vania!"

Ways to Use
Cartoons

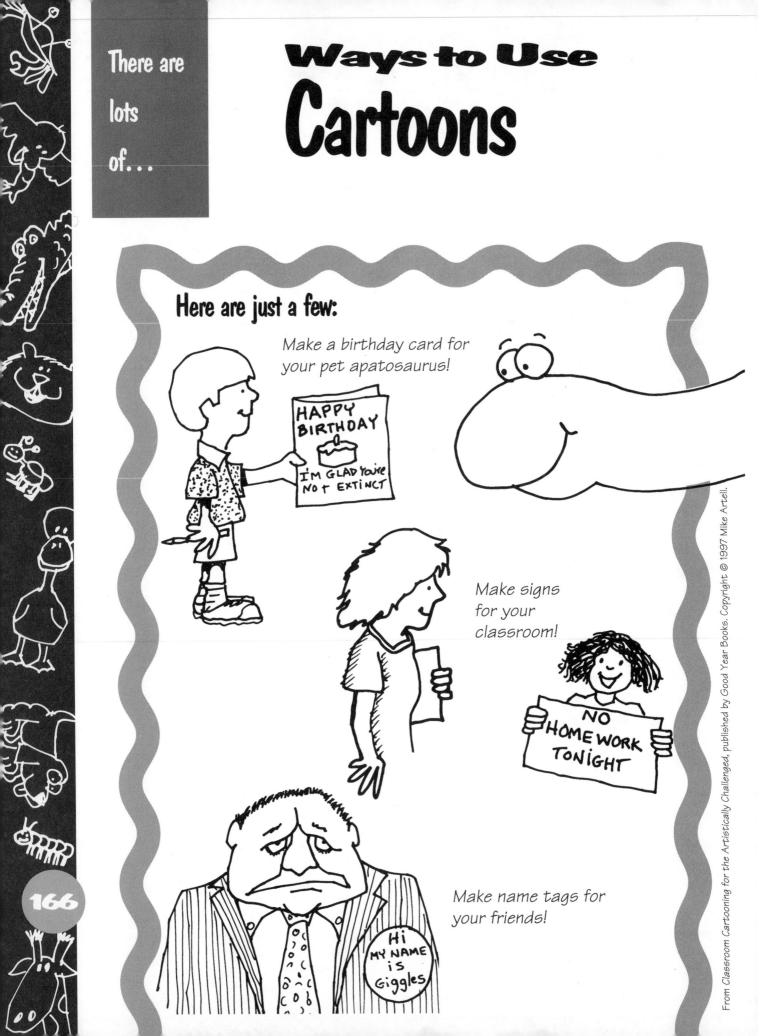

Here are just a few:

Make a birthday card for your pet apatosaurus!

HAPPY BIRTHDAY

I'M GLAD You're NOT EXTINCT

Make signs for your classroom!

NO HOME WORK TONIGHT

Make name tags for your friends!

Hi MY NAME is Giggles

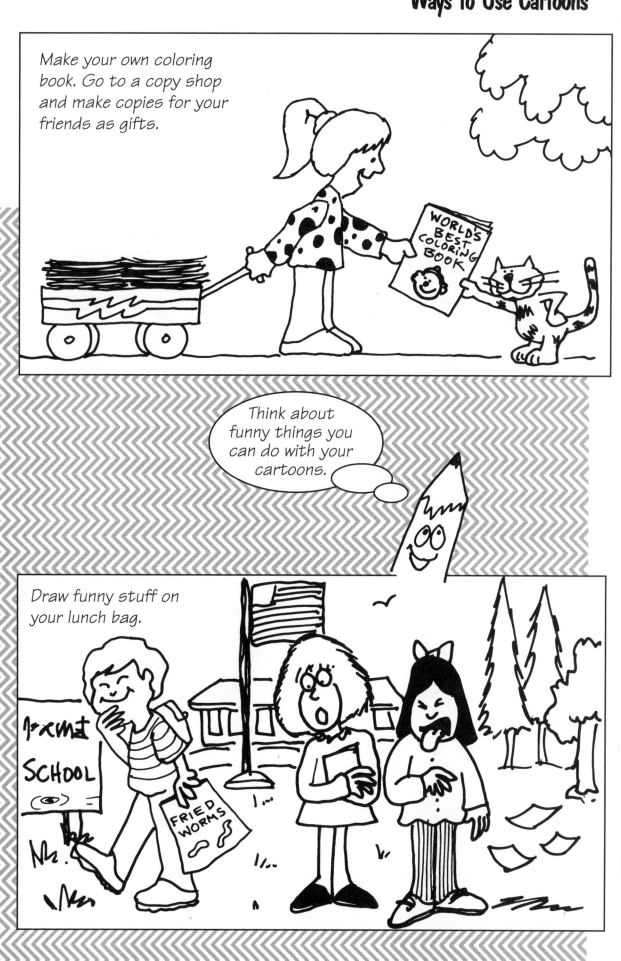

Make your own coloring book. Go to a copy shop and make copies for your friends as gifts.

Think about funny things you can do with your cartoons.

Draw funny stuff on your lunch bag.

I hope you enjoy using Classroom Cartooning for the Artistically Challenged and that you'll write me with your comments, suggestions, and success stories. It's always great fun for me to read letters from teachers and students, so don't be shy.

If you'd like a reply, please be sure to include a self-adressed, stamped envelope.
Write to:

 Mike Artell
 P.O. Box 1819
 Covington, LA 70434